TATTOO A BANANA

and Other Ways to Turn Anything and Everything into Art

Phil Hansen

A Perigee Book

A PERIGEE BOOK

Published by the Penguin Group

Penguin Group (USA) Inc.

375 Hudson Street, New York, New York 10014, USA

Penguin Group (Canada), 90 Eglinton Avenue East, Suite 700, Toronto, Ontario M4P 2Y3, Canada (a division of Pearson Penguin Canada Inc.) • Penguin Books Ltd., 80 Strand, London WC2R ORL, England • Penguin Group Ireland, 25 St. Stephen's Green, Dublin 2, Ireland (a division of Penguin Books Ltd.) • Penguin Group (Australia), 250 Camberwell Road, Camberwell, Victoria 3124, Australia (a division of Pearson Australia Group Pty. Ltd.) • Penguin Books India Pvt. Ltd., 11 Community Centre, Panchsheel Park, New Delhi— 110 017, India • Penguin Group (NZ), 67 Apollo Drive, Rosedale, Auckland 0632, New Zealand (a division of Pearson New Zealand Ltd.) • Penguin Books (South Africa) (Pty.) Ltd, 24 Sturdee Avenue, Rosebank, Johannesburg 2196, South Africa

Penguin Books Ltd., Registered Offices: 80 Strand, London WC2R ORL, England

While the author has made every effort to provide accurate telephone numbers and Internet addresses at the time of publication, neither the publisher nor the author assumes any responsibility for errors or for changes that occur after publication. Further, the publisher does not have any control over and does not assume any responsibility for author or third-party websites or their content.

TATTOO A BANANA

Copyright © 2012 by Phil Hansen

First edition: June 2012

ISBN: 978-0-399-53747-9

PRINTED IN THE UNITED STATES OF AMERICA

10 9 8 7 6 5 4 3 2 1

Most Perigee books are available at special quantity discounts for bulk purchases for sales promotions, premiums, fund-raising, or educational use. Special books, or book excerpts, can also be created to fit specific needs. For details, write: Special Markets Penguin Group (USA) Inc., 375 Hudson Street, New York, New York 10014.

ALWAYS LEARNING PEARSON

ACKNOWLEDGMENTS

Deep gratitude toward my editor, Marian Lizzi, for believing in my work and making this book possible. Also thanks to my agents, Frank Weimann and Katherine Latshaw, for being awesome at what they do.

I couldn't have done this without the assistance of my wife, Joy, who enthusiastically tried out each project and provided valuable feedback. I'm very thankful to the rest of the family for their understanding and unwavering support.

Special thanks to those who follow my work. You greatly contribute to my growth and experiences as an artist. And lastly, thank you for poking, inflating, smearing, etc, your way through this book. I can't wait to see what you do with it.

3

INTRODUCTION

Like any other kid, I did a lot of exploring and experimenting when I was little: finger painting, playing with dirt, pouring honey on my cat... I didn't start doing "art" until 8th grade when my mom signed me up for art lessons. I quit after going to a few classes, as it seemed that the teacher only wanted to demonstrate his own artistic style, not to foster my creative needs. So I started to explore my own interests.

In high school I became obsessed with pointillism — so much so that I ended up damaging nerves in my right hand and developed a permanent jitter. I spent a few years away from art because I couldn't do the pointillism that I loved. When I decided to give it another shot, I had to find other ways of making art, so I began experimenting with fragmentation of different materials and became enthralled by the exploration, the process, and the breakthroughs.

In bringing my work to the public, I began documenting the creation process through time-lapse videos, showing that the process is where it all happens — the idea, the painstaking effort, the fun. Along the way,

I've received a lot of emails from art students, teachers, and people who considers themselves "non-artists," interested in learning about creating art with different materials. In making this book, I wanted to show projects that anyone can do with what they have at home. This took me back to everyday creativity, which is what attracted me to art in the first place. I hope that by going back to the fundamentals, you can discover your own creative pursuits.

This book isn't about making beautiful art, although that's often the wonderful by-product of a creative endeavor. And forget about buying a bunch of intimidating art supplies. Think back to when you were a kid. Maybe we're smart enough now not to pour honey on the cat, but sometimes we're also so "smart" that we don't let our minds open up to new possibilities. So go ahead: tattoo a banana.

Commonsense disclaimer: Handle all sharp objects, electrical appliances, and other tools with care. Although it may be tempting to eat your art at times, DON'T! (unless it's comprised of edibles only)

PROJECT LIST

Tattoo a Banana

TAKE A PUSHPIN OR NEEDLE AND A BANANA.

CHOOSE A PATTERN AND CUT IT OUT. ⟶

TAPE IT ONTO THE BANANA.

POKE HOLES THROUGH THE
LINES OF THE PATTERN.

KEEP HOLES CLOSE AND TIGHT. YES NO

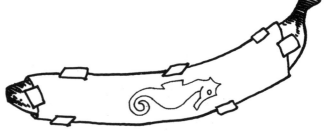

TAKE THE PAPER
OFF WHEN COMPLETE.

Your image will be visible
immediately, and will look
awesome in 24 hours.

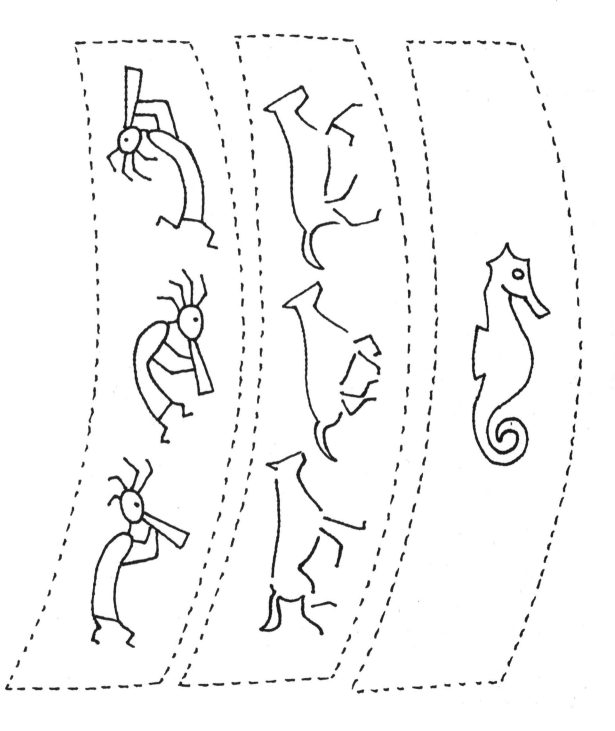

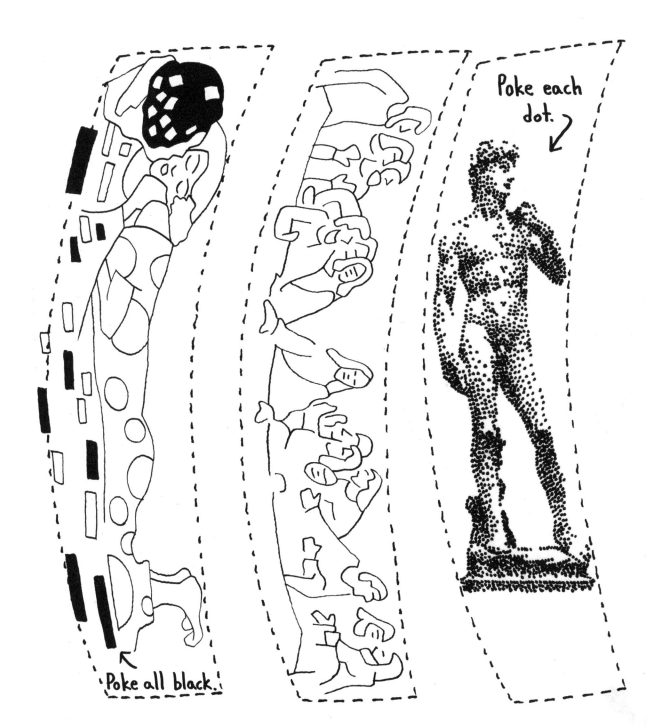

Poke each dot.

Poke all black.

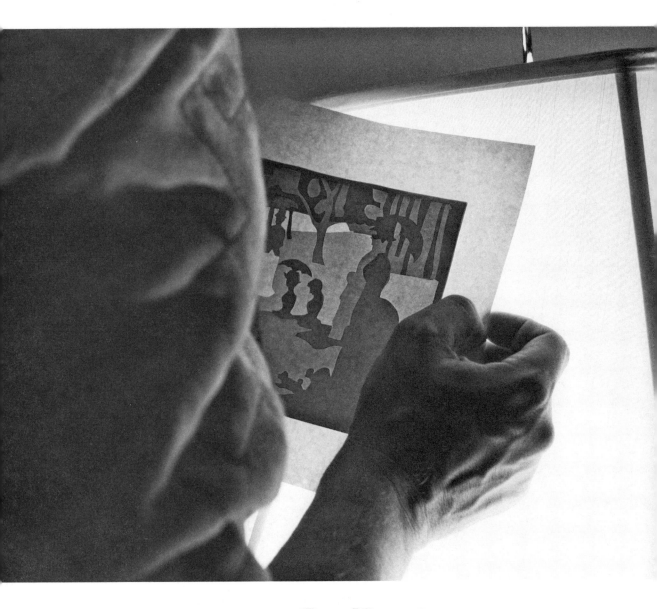

FROM A LIGHT RUNS THROUGH IT ON PAGE 118

The Scan Whisperer

PUT YOUR HAND ON A SCANNER AND SCAN IT.

DO IT AGAIN WHILE SLOWLY MOVING
YOUR HAND AS IT SCANS.

DO THE SAME WITH YOUR FACE.

ROLL,
SLIDE,
SQUISH,
TWIST,
YOUR WAY TO A
NEW PROFILE PICTURE.

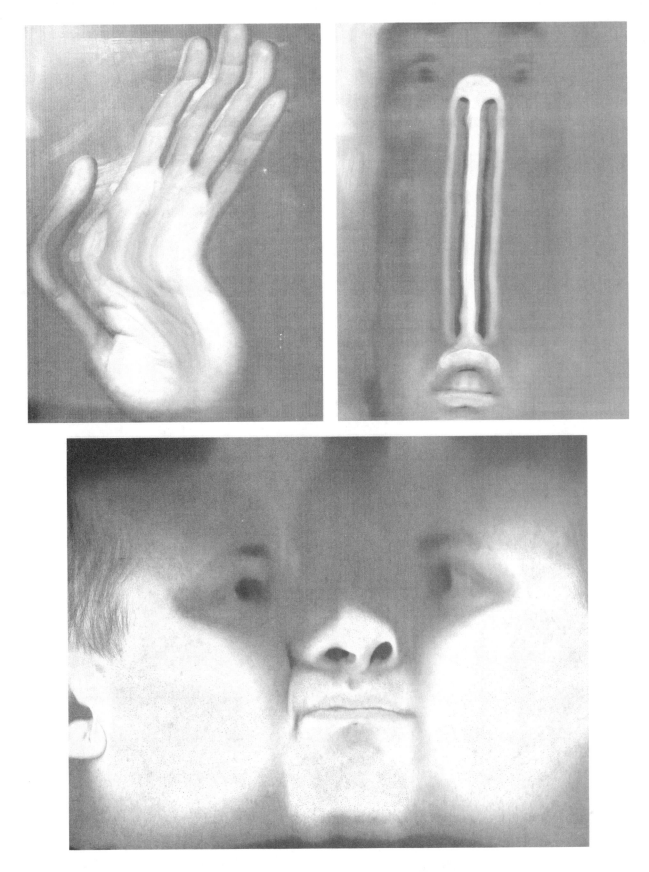

Delete this Cookie

GRAB A COOKIE WITH FILLING.

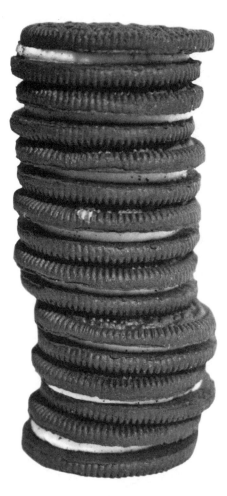

PEEL IT APART PERFECTLY.

USE THIS

EAT THIS

CUT SHAPES INTO THE CREAM.

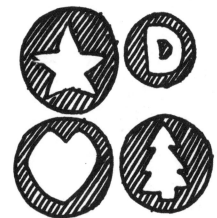

Use a
toothpick
for
detail.

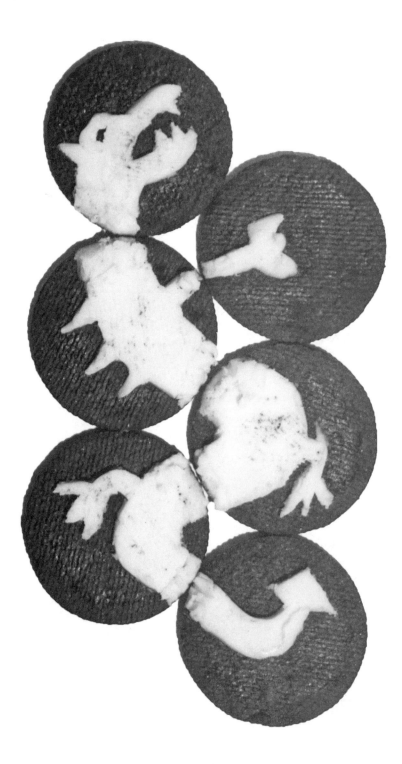

Love it or Leaf it

CUT OUT THE SHAPES. ⟶

PUT THEM ON FLAT LEAVES AND CUT THEM OUT.

ORGANIZE THE LEAVES ACCORDING
TO THIS PATTERN. ⟶

A LITTLE OVERLAP.

WHEN YOU ARE
DONE, LEAVE IT
TO DRY AND WATCH
THE PICTURE SHRIVEL.

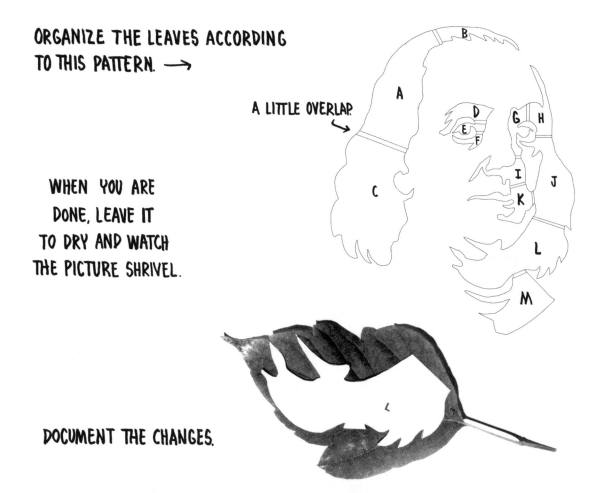

DOCUMENT THE CHANGES.

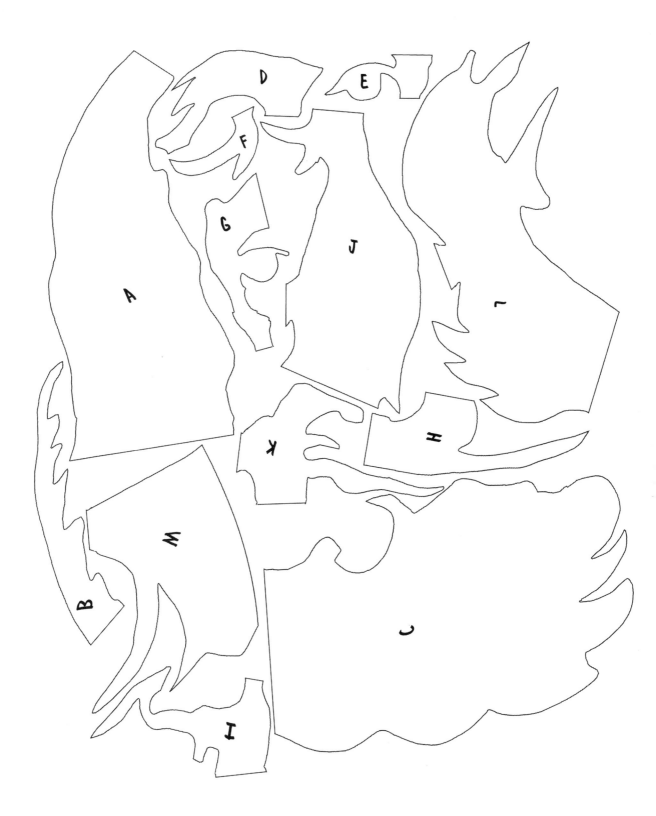

SNOW NOT SO WHITE

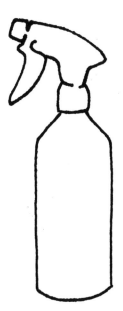

GRAB AN OLD SPRAY BOTTLE.

FILL IT WITH WATER.

PUT SOME FOOD COLORING IN IT.

AND GO SPRAY A MESSAGE IN THE SNOW.

He's Full of Hot RRRRR

CUT OUT THE NEXT PAGE. ⟶

PUT IT INSIDE A WHITE PLASTIC BAG.
TRACE THE FACE ONTO THE BAG WITH A
PERMANENT MARKER.

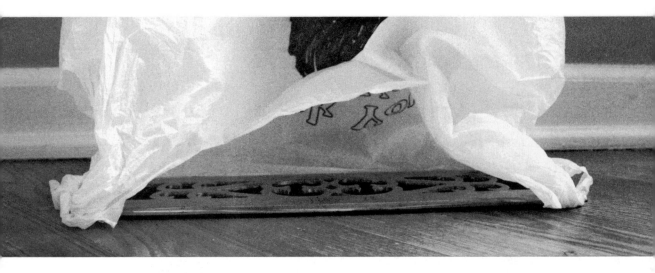

WRAP AROUND VENT PLATE. TURN ON THE AIR!

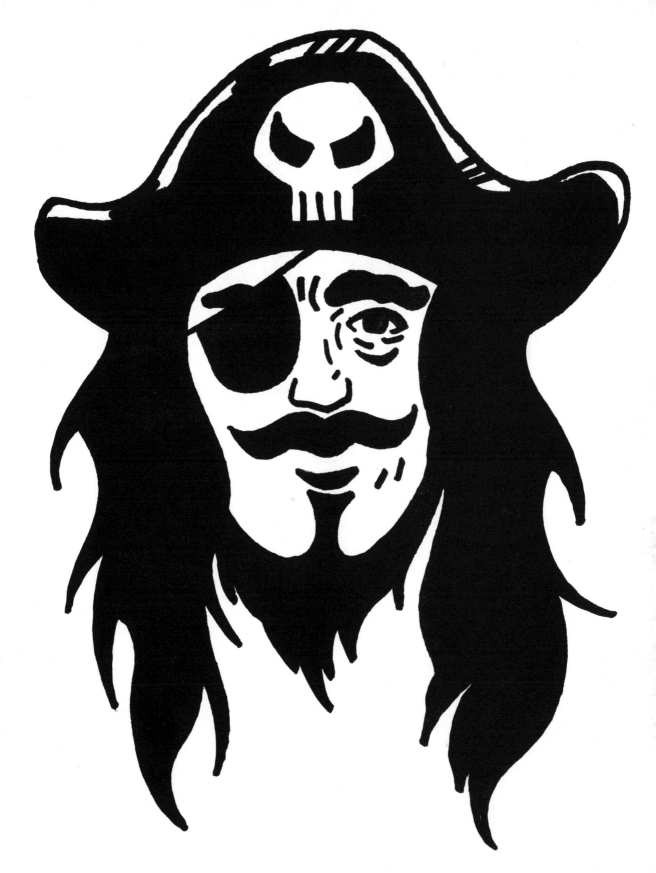

TAKE 5 PLASTIC BAGS, CUT EACH BAG ACCORDING TO THE DOTTED LINES.

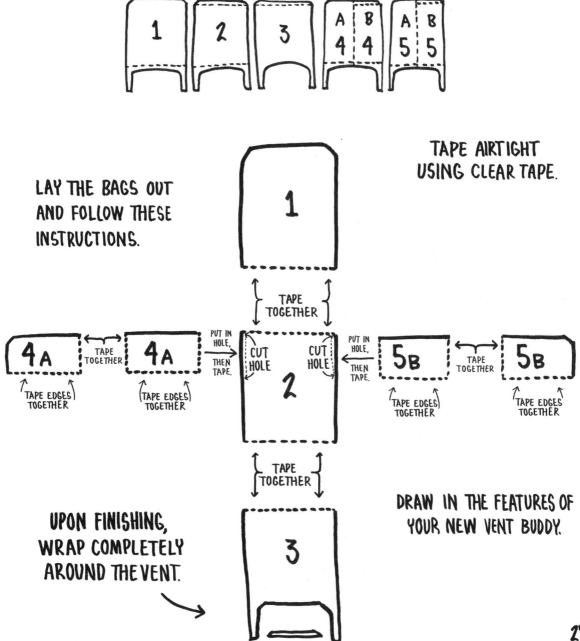

LAY THE BAGS OUT AND FOLLOW THESE INSTRUCTIONS.

TAPE AIRTIGHT USING CLEAR TAPE.

1

TAPE TOGETHER

4A | TAPE TOGETHER | 4A
PUT IN HOLE, THEN TAPE.
CUT HOLE | 2 | CUT HOLE
PUT IN HOLE, THEN TAPE.
5B | TAPE TOGETHER | 5B

TAPE EDGES TOGETHER

TAPE TOGETHER

DRAW IN THE FEATURES OF YOUR NEW VENT BUDDY.

UPON FINISHING, WRAP COMPLETELY AROUND THE VENT.

3

Scribble Wars

CUT OUT THE NEXT TWO PAGES.

TAPE THEM TOGETHER ON THE BACK.

SCRIBBLE IN THE L
AREAS LIKE THIS.→

M LIKE THIS.→

D LIKE THIS.→

IF A SECTION IS NOT MARKED, LEAVE IT BLANK.

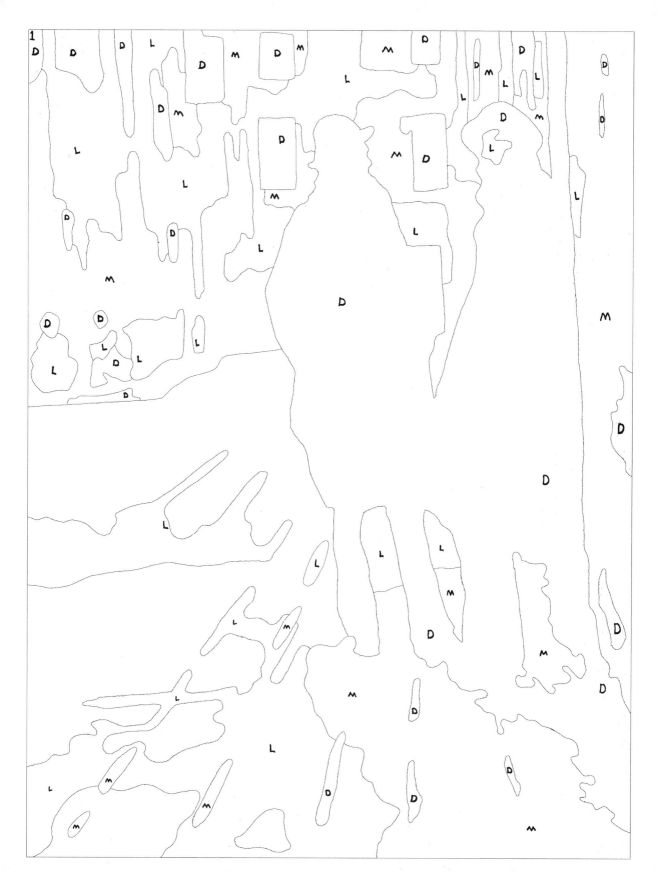

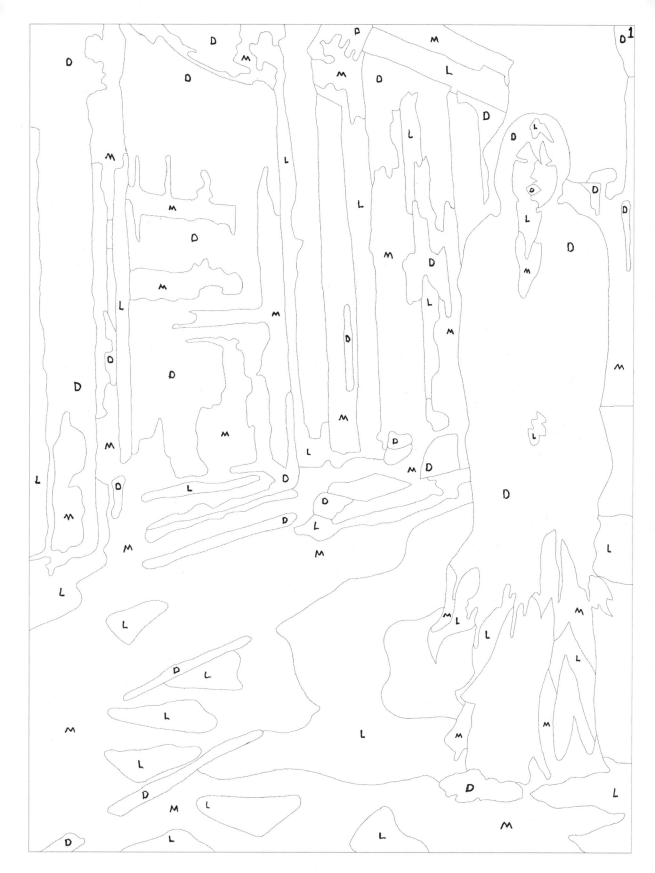

REDUCE REUSE REPUZZLE

TAKE A 25-PIECE PUZZLE.
SOLVE IT.
FLIP IT OVER.

WRITE A MESSAGE ON IT,
PAINT A PICTURE ON IT,
WRITE A STORY.

YOU JUST CREATED
YOUR OWN PUZZLE.

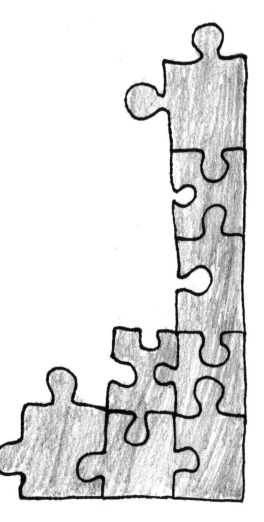

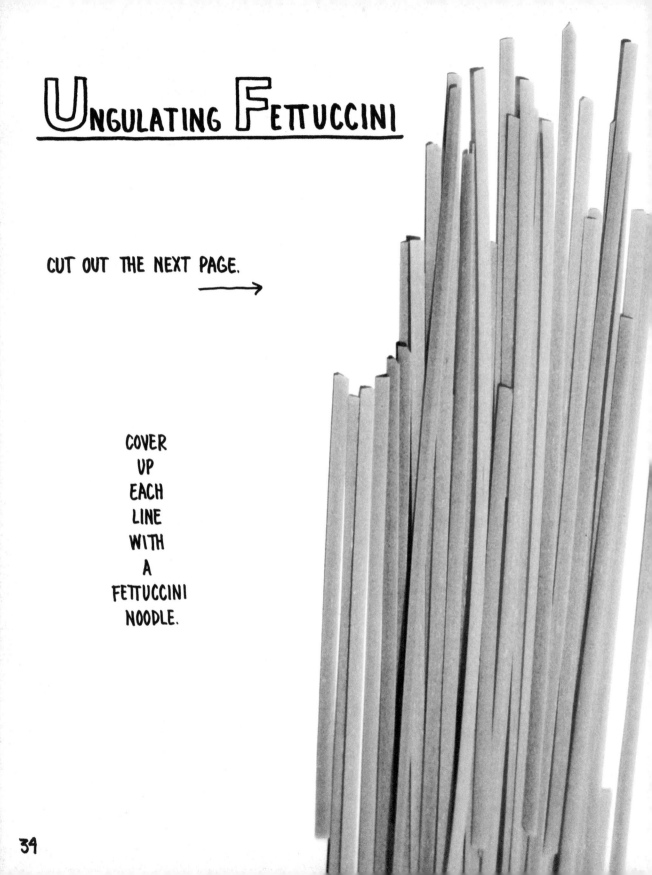

Undulating Fettuccini

CUT OUT THE NEXT PAGE.
→

COVER
UP
EACH
LINE
WITH
A
FETTUCCINI
NOODLE.

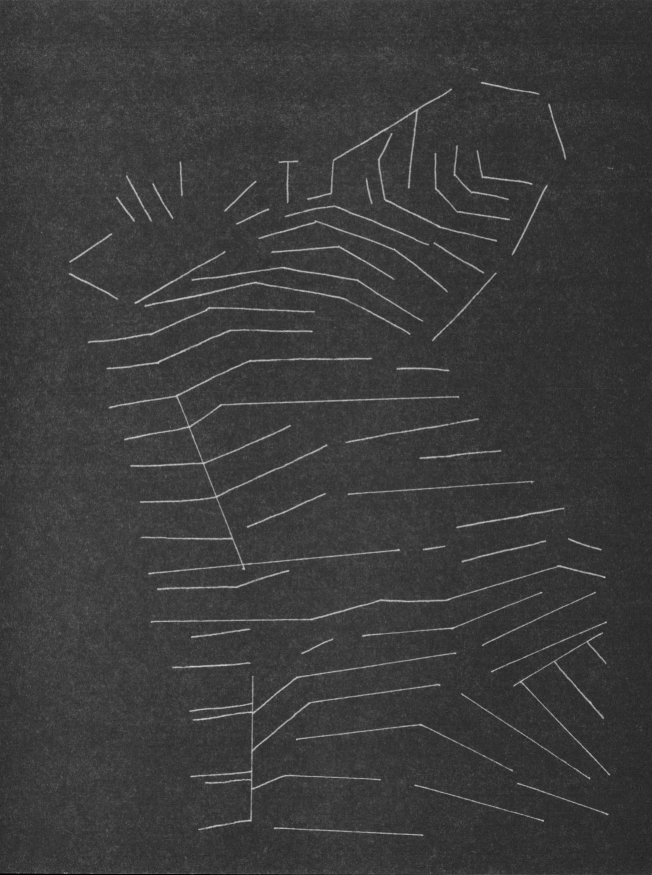

Name that Soup

POUR A CAN OF ALPHABET SOUP INTO A BOWL.

PICK OUT THE LETTERS
THAT SPELL YOUR NAME.

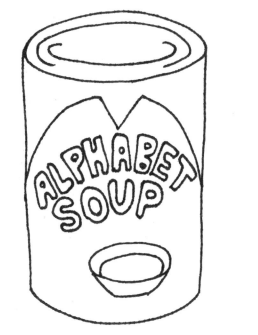

PUT THEM ON
A PLATE. TAKE
A PHOTO AND USE IT
AS YOUR ONLINE SIGNATURE.

WORTH MORE THAN A GRAHAM OF GOLD

CUT OUT THOSE SHAPES. \longrightarrow

PLACE EACH ONE ON A GRAHAM CRACKER.

USING A KNIFE,
SCRAPE,
CUT,
AND
CHIP
OUT
EACH
SHAPE.

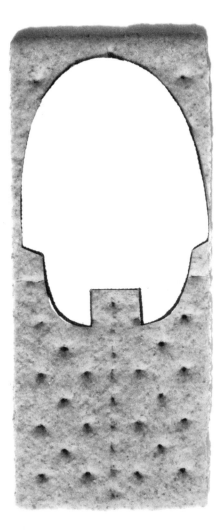

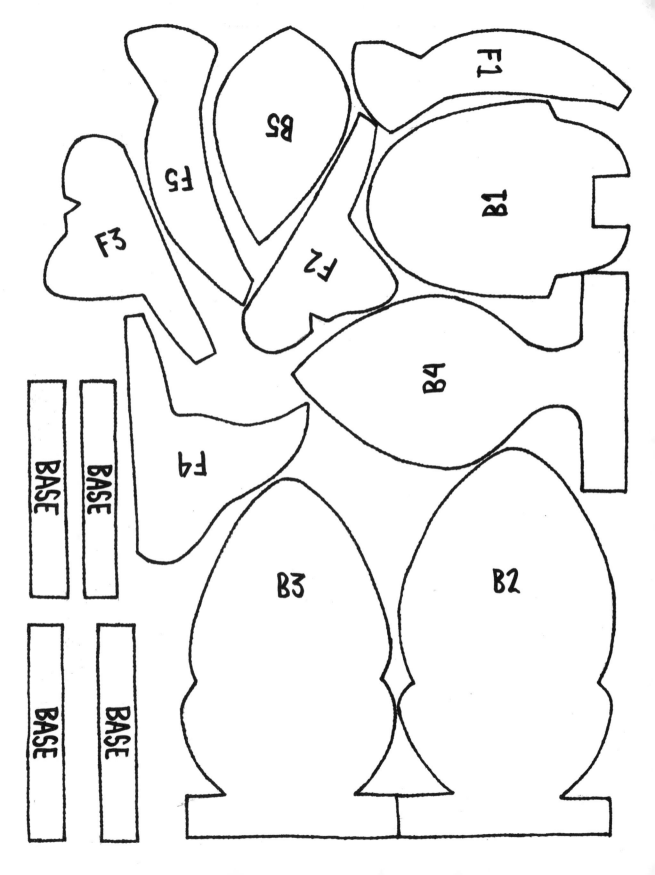

GLUE THEM TOGETHER WITH PEANUT BUTTER.

THIS IS HOW THEY
SHOULD LOOK STACKED.

THIS IS THE
ORDER THEY GO IN.

F1 F2 F3 F4 F5

B1 B2 B3 B4 B5

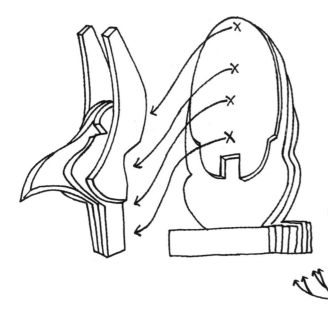

PLACE TWO BASES
IN FRONT
AND TWO IN BACK.

GLOORAH

CUT OUT THE NEXT PAGE. ⟶

PUT IT ON A TABLE.

PUT A PIECE OF PLASTIC WRAP OVER IT.
COVER UP THE ARMY MAN WITH WHITE GLUE.

LEAVE IT FOR 24-48
HOURS TO DRY. PEEL
IT OFF AND STICK IT
TO THE WINDOW.

If the glue goes
outside the lines,
wait for it to dry
and then cut it off.

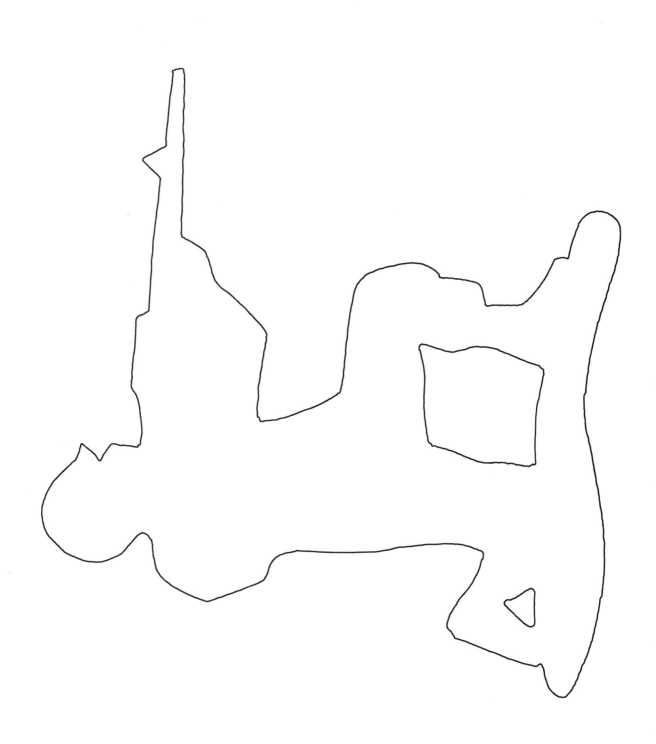

PICK A SHAPE, IMAGE, OR LOGO
AND OUTLINE IT WITH GLUE.

WRITE YOUR NAME WITH GLUE
AND UNDERLINE IT TO CONNECT
THE LETTERS.

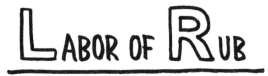 LABOR OF RUB

CUT OUT THE FOLLOWING PAGE. ⟶

RUB WITH A PENCIL ON INTERESTING SURFACES.

RUB WITH THE PENCIL THIS WAY, NOT THIS WAY.

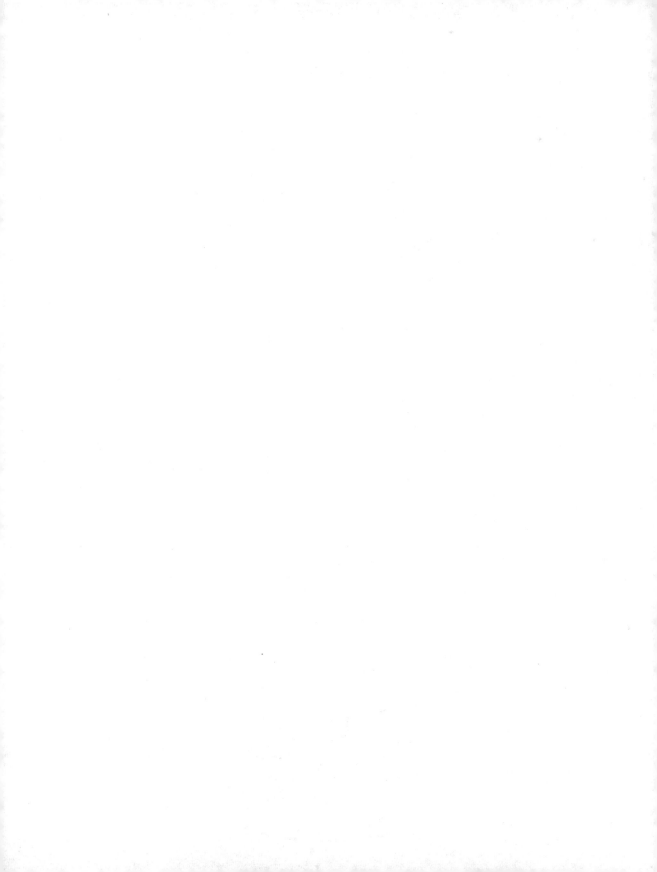

SOME DIFFERENT SURFACES FROM MY HOUSE.

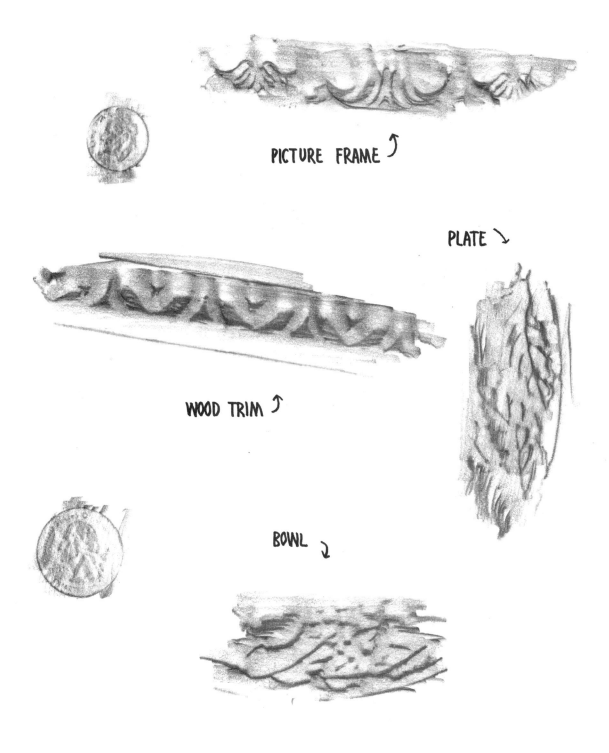

PICTURE FRAME ⤴

PLATE ⤵

WOOD TRIM ⤴

BOWL ⤵

ESTATED

DRAW YOUR STATE HERE. ↙

WHAT DO YOU SEE?
FIND AND DRAW THE IMAGES HIDING WITHIN.

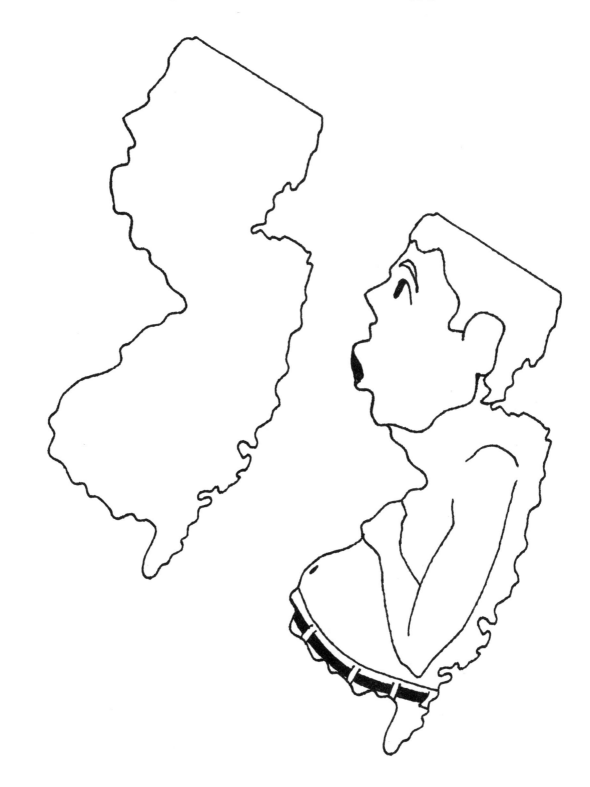

THE ERASERCIST

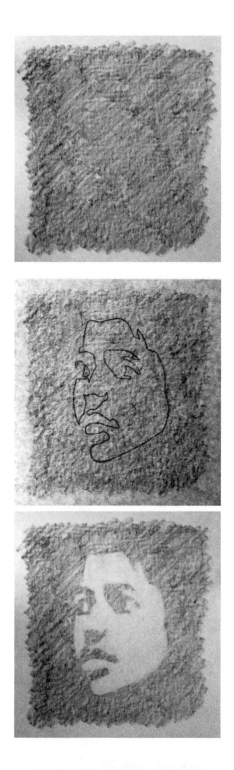

CUT OUT THE NEXT PAGE,
THEN SHADE IN THE BLANK
SIDE LIKE THIS. →

PUT IT ON A WINDOW SO YOU
CAN SEE THROUGH IT.
ERASE THE X AREAS.

THEN REMOVE IT FROM THE
WINDOW TO REVEAL THE IMAGE.

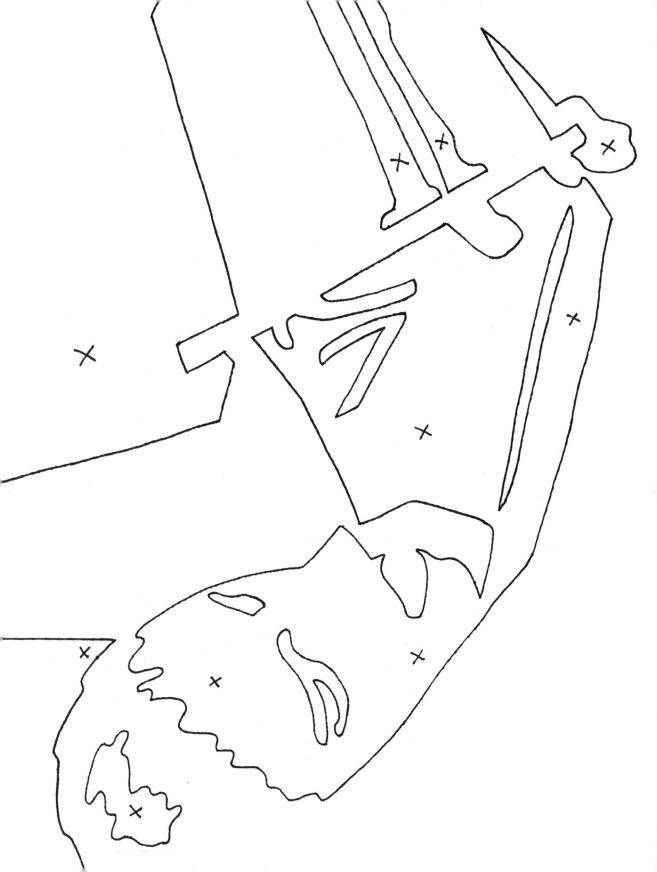

FROM H'S FULL OF HOT RRRRR ON PAGE 29

Cup Man

NAH NAH NAH NAH
NAH NAH NAH NAH

Cup Man

FIND FOUR 16oz STYROFOAM CUPS.

CUT OUT THE THREE TEMPLATES ON THE NEXT TWO PAGES.

STEP 1 PLACE ON CUP.

TAPE

2

TAPE

WRAP

STEP 2 CUT OUT.

2

ON THE FOURTH CUP, COLOR THE TOP HALF BLACK.

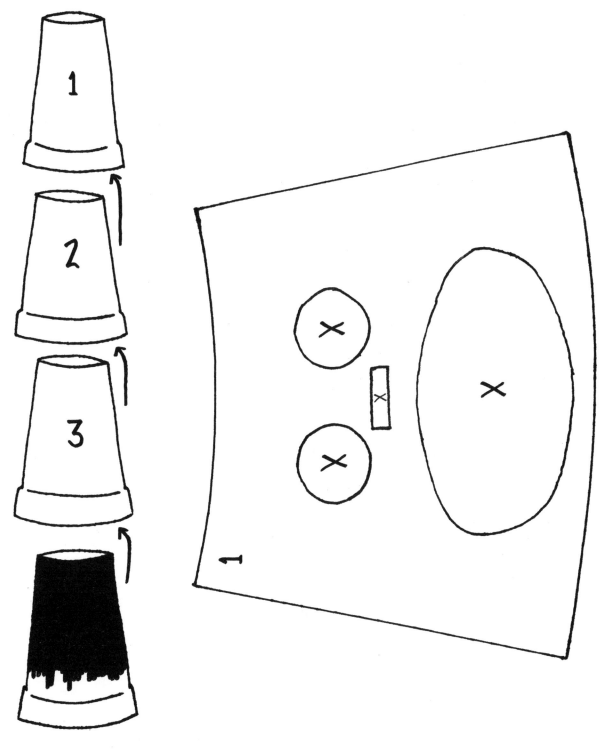

STACK THEM
IN THIS ORDER.

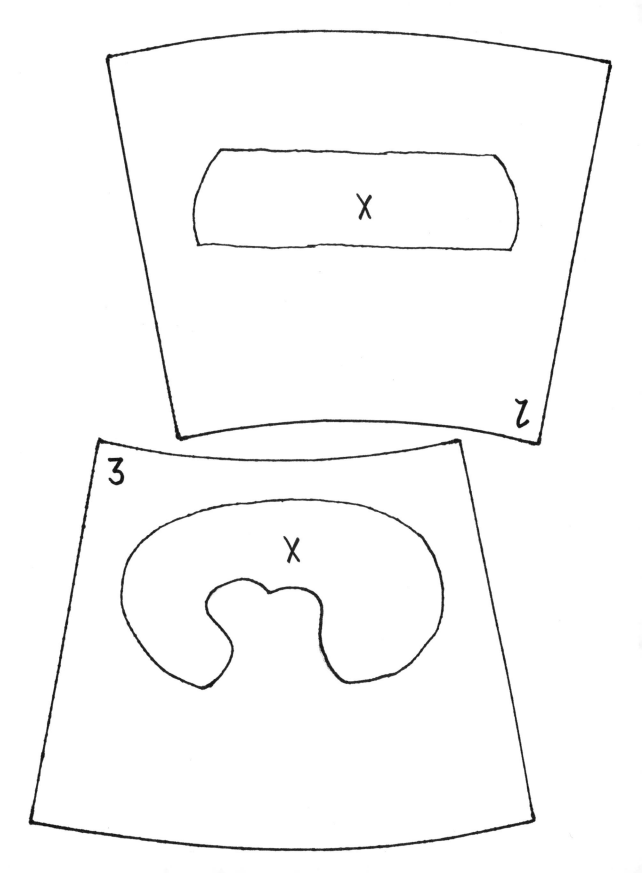

WITH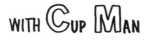

THIS CHALLENGE YOURSELF IS SO CHALLENGING THAT
IT NEEDS TO BE DOWNLOADED FROM

tattooabanana.com

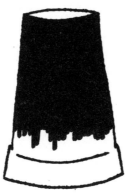

You Little Cracker Snapper

FIND A FLAT, WHITE, LARGE
SURFACE FOR THIS PROJECT.

GET A BOX OF
SQUARE CRACKERS.

BREAK AND GET RID OF THE X PARTS, THEN PLACE ON
YOUR SURFACE ACCORDING TO THE DIAGRAM. ⟶

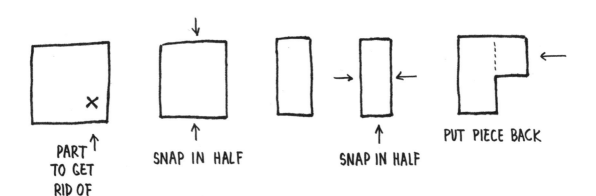

PART
TO GET
RID OF

SNAP IN HALF

SNAP IN HALF

PUT PIECE BACK

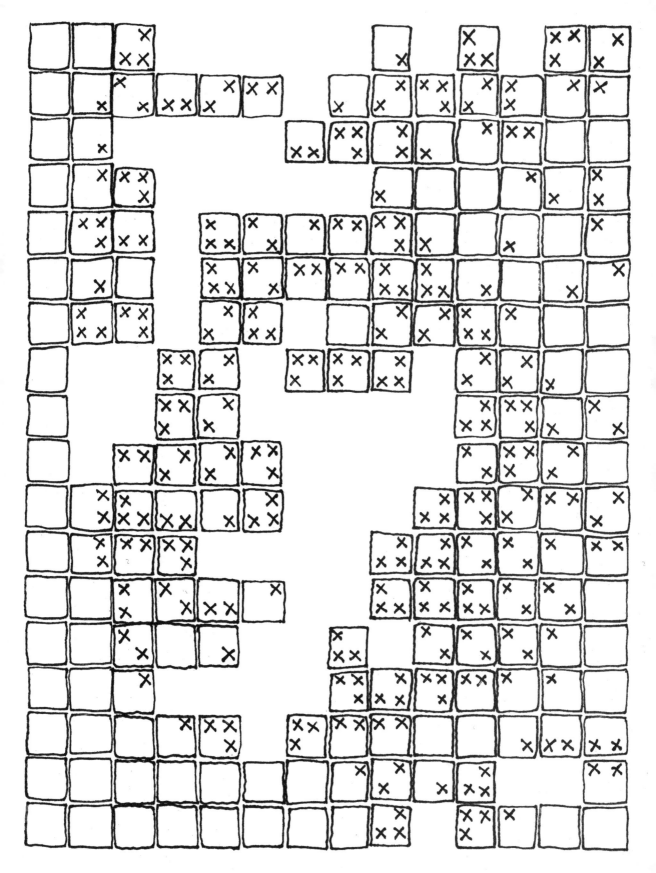

Beauty is in the Eye of the Peeler

CUT OUT THE NEXT PAGE. →

COVER UP ALL THE X AREAS
WITH POTATO SKIN PEELINGS.

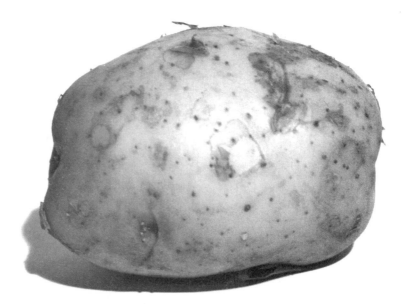

TRIM FOR THE DETAILS.

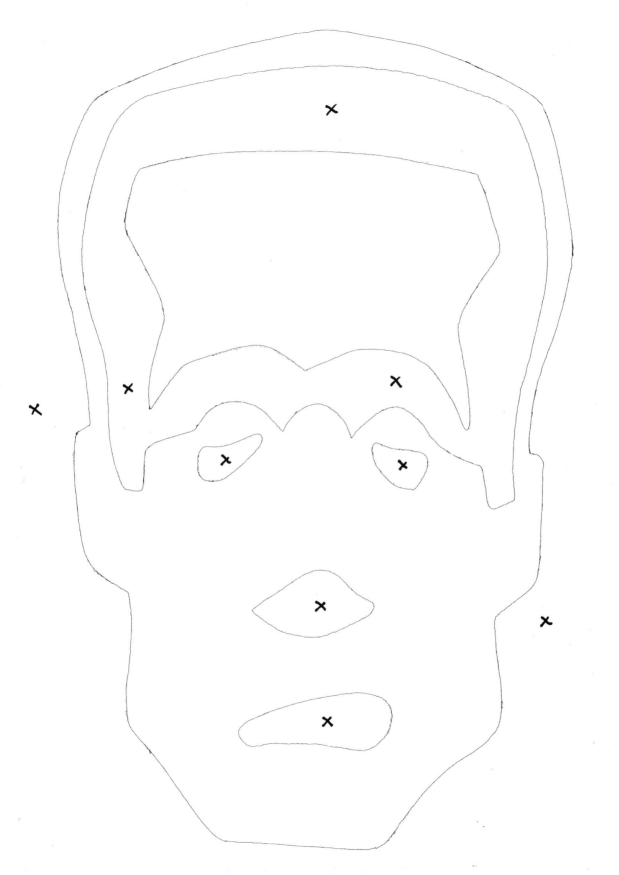

A Text Worth 38 Points

NEXT TIME YOU WANT TO SEND
SOMEONE A TEXT MESSAGE,
WRITE THE MESSAGE WITH
SCRABBLE PIECES.

TAKE A PHOTO.
SEND THE PHOTO.

WRITE PUNCTUATION
ON THE BLANKS.

Eternal Sunshine of the Cardboard Kind

GET SOME SCRAP CARDBOARD.
CUT 13 2x4 inch PIECES.
CUT OUT THE PATTERNS ON THE NEXT TWO PAGES. ⟶

CUT OUT AND REMOVE THE X AREAS IN THE PATTERNS.

PLACE THE PATTERN
ON THE CARDBOARD.

DON'T USE SCISSORS.
CUT YOUR CARDBOARD
USING A BOX CUTTER.

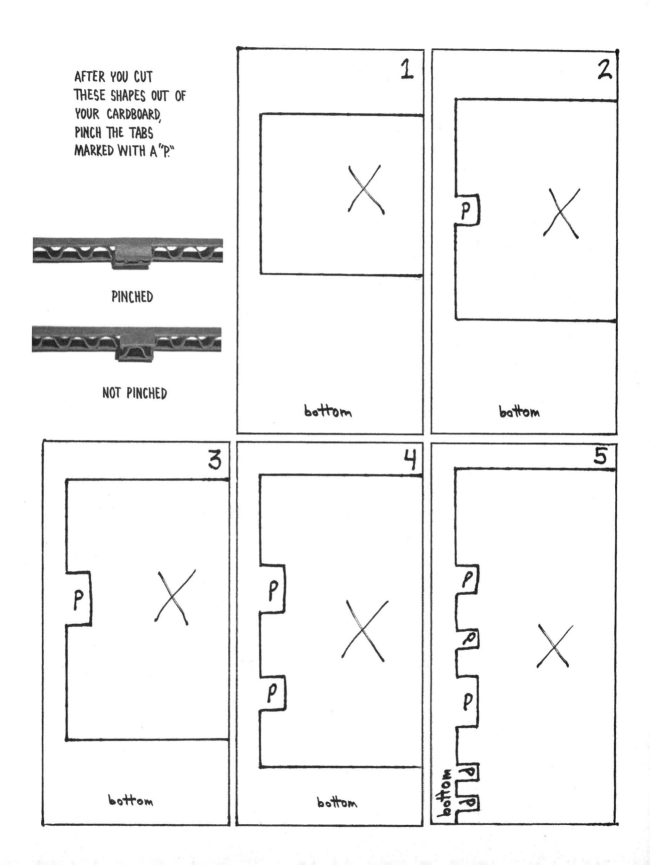

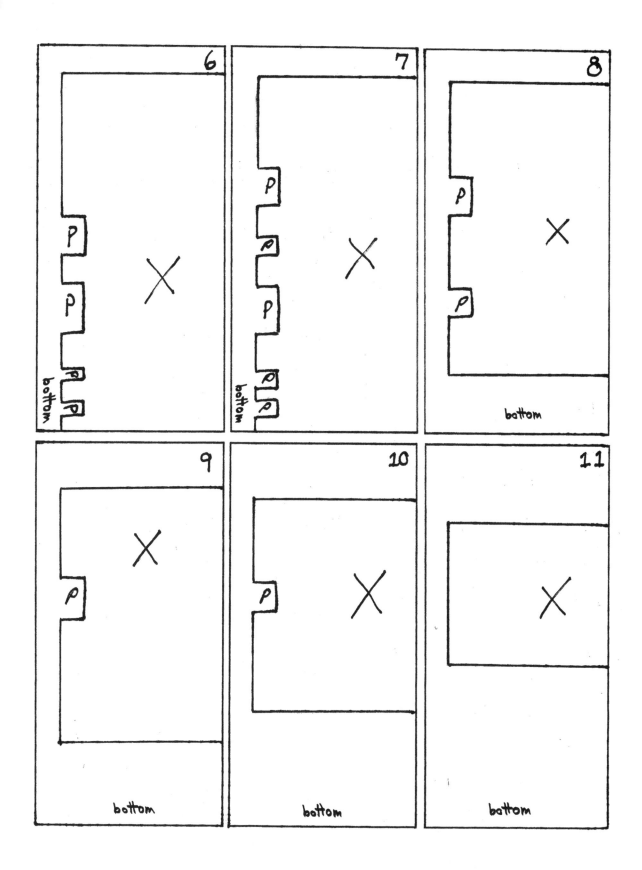

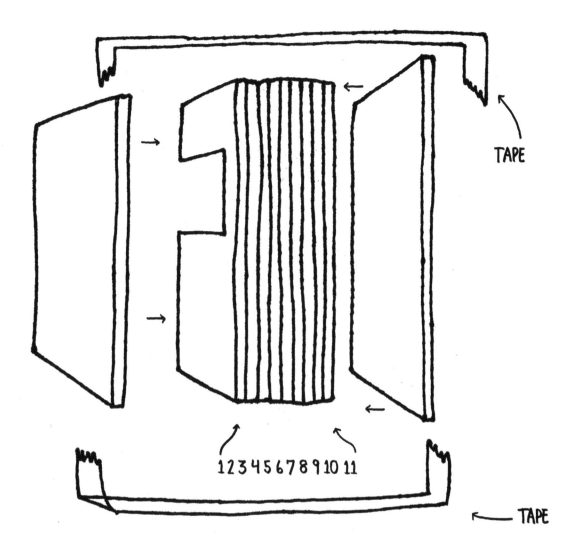

TAPE

1 2 3 4 5 6 7 8 9 10 11

TAPE

WHEN YOU ARE FINISHED,
PUT A PIECE OF BLANK CARDBOARD
ON EACH END AND TAPE TOGETHER.

LOOK THROUGH THE HOLES TO SEE YOUR CREATION.

THE DEVIL WEARS NON-RECYCLABLES

TAKE A PLASTIC GROCERY BAG.

SEARCH FOR A ZEBRA OR
LEOPARD PATTERN ONLINE,
OR ANY PATTERN OF
YOUR CHOICE.

STRETCH AND TAPE YOUR BAG.
TRACE THE PATTERN
WITH A PERMANENT MARKER.

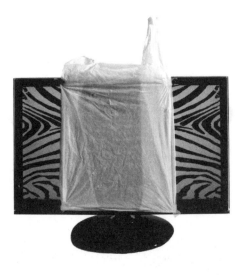

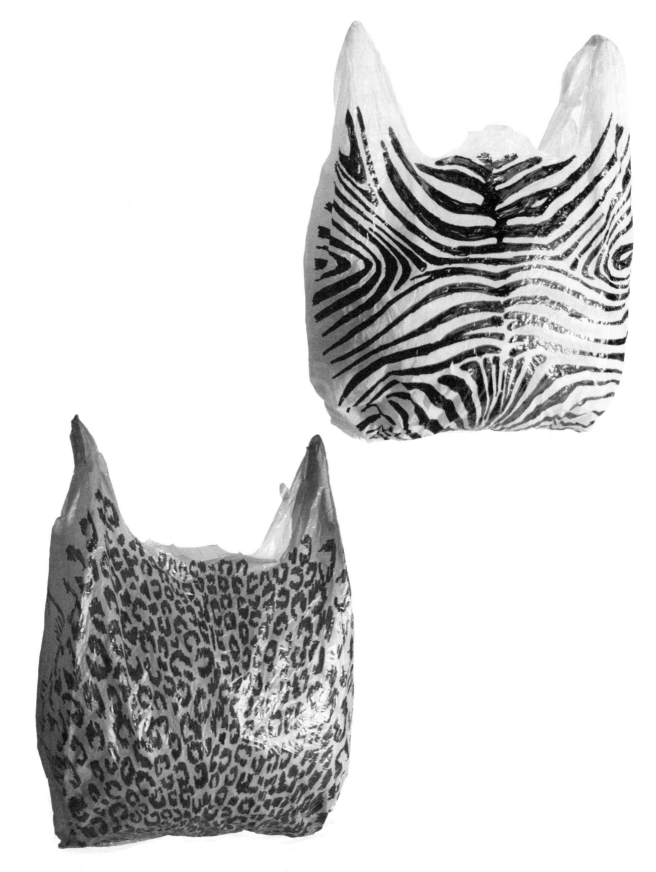

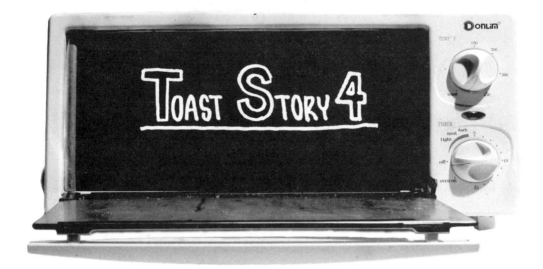

Toast Story 4

YOU NEED A TOASTER OVEN FOR THIS PROJECT,
<u>NOT</u> A REGULAR TOASTER.

USE THE IMAGES ON THE NEXT
PAGE AS TEMPLATES AND
CUT THE SAME SHAPES
OUT OF ALUMINUM FOIL.

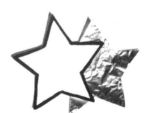

PUT YOUR ALUMINUM
FOIL IMAGE
COMPLETELY FLAT ON A
PIECE OF BREAD.

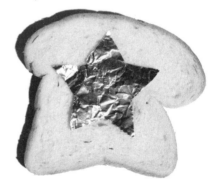

TOAST IT.

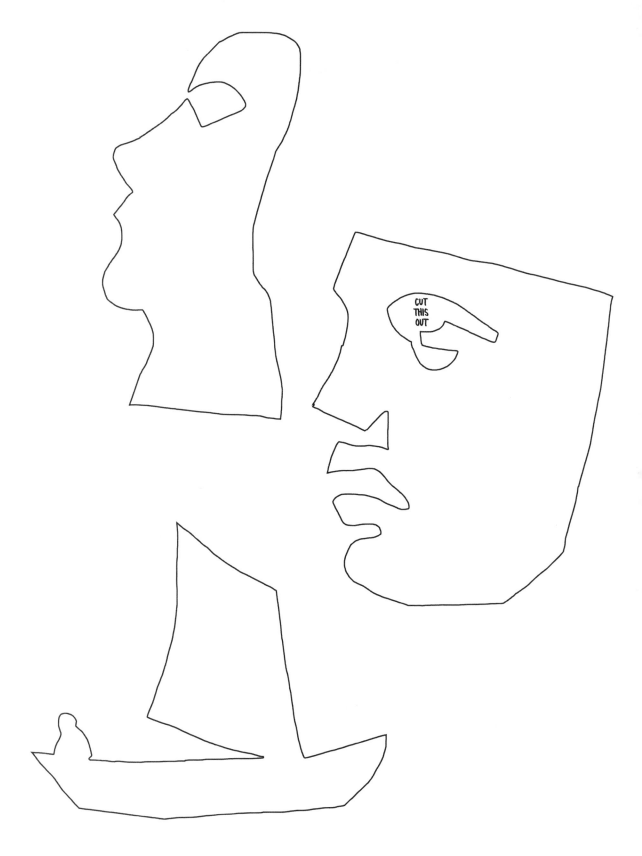

CUT
THIS
OUT

EXPERIMENT TO CREATE A MORE DETAILED IMAGE.

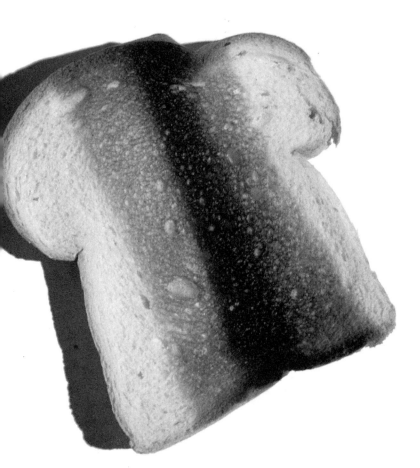

TOAST WITH A PATTERN,
THEN RETOAST WITH ANOTHER
PATTERN TO CREATE LIGHT,
MEDIUM, AND DARK AREAS.

WOE IS MMMMM

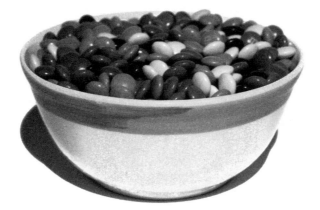

CUT OUT THE NEXT TWO PAGES.

TAPE THEM TOGETHER.

FIND HARD CANDIES WITH THESE COLORS. →

BLUE = bl
RED = r
BROWN = b
ORANGE = o
YELLOW = y
GREEN = g

PUT THEM ON THE PATTERN.

To see the image more clearly, view from farther away.

WITH Woe is Mmmmmm

THIS CHALLENGE YOURSELF IS SO CHALLENGING THAT
IT NEEDS TO BE DOWNLOADED FROM

tattooabanana.com

Chalk it up to a Walk

GRAB A PIECE OF CHALK.

GO ON A WALK.

LOOK FOR A CRACK THAT
RESEMBLES PART OF A FACE.

COMPLETE THE FACE.

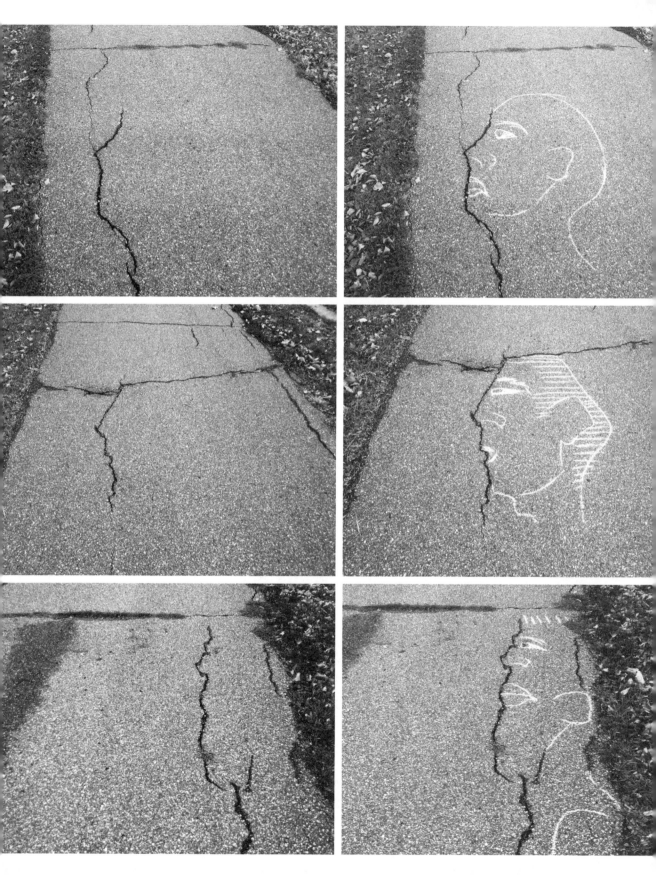

101 USES FOR MONA LISA: #38

CUT OUT THE NEXT TWO PAGES, TAPE TOGETHER.

PLACE ON A COOKIE SHEET AND
TAPE WAX PAPER OVER IT.

MAKE OR BUY A BATCH OF SUGAR COOKIE BATTER.
IN A SEPARATE BOWL MIX ⅓ OF THE BATTER
WITH COCOA UNTIL DARK BROWN.

PUT THE REGULAR BATTER ON SECTIONS MARKED L.
PUT THE COCOA MIX ON D SECTIONS.

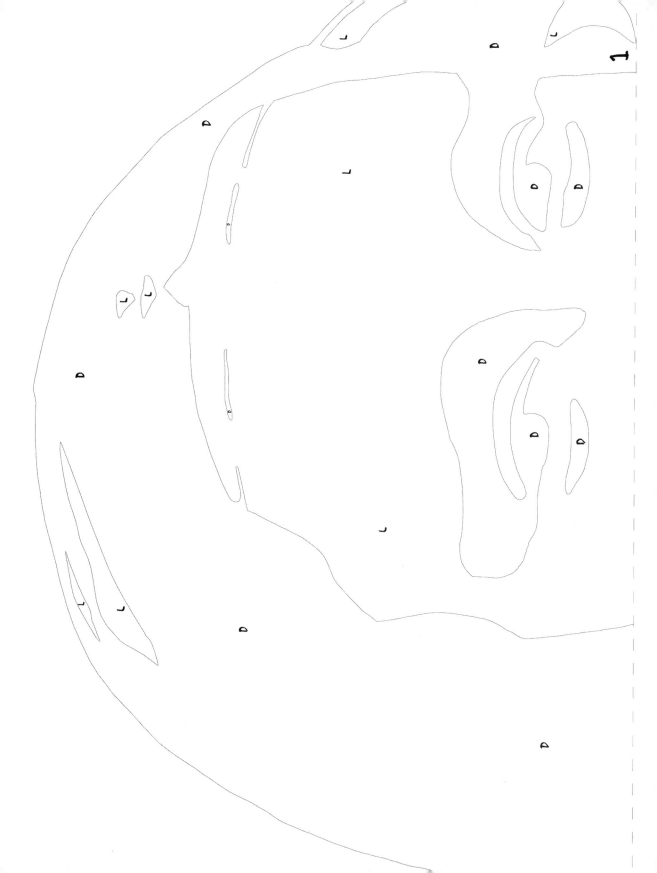

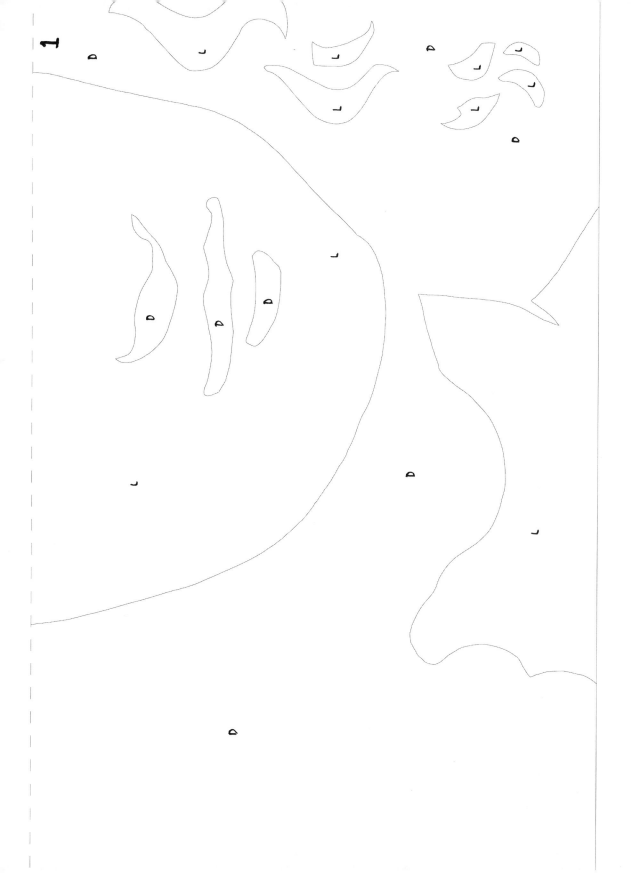

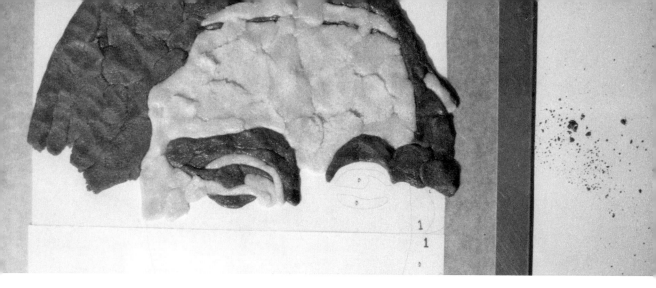

APPLY ABOUT ⅛ INCH THICK

WHEN COMPLETE, REMOVE THE TAPE
ON THE WAX PAPER.

PUT A GREASED COOKIE SHEET ON TOP, FACE DOWN.
VERY CAREFULLY FLIP OVER.

REMOVE TOP COOKIE SHEET, PAPER, AND WAX PAPER.

BAKE.

For ease of removal,
do not overbake.

SERVE.

Tape me to the Moon

CUT OUT THE PATTERN. →

TAPE THE BACK OF IT TO A WINDOW.

PUT SCOTCH TAPE ON
THE WINDOW AROUND
THE PATTERN.

REMOVE THE PATTERN.

ENJOY YOUR GLOWING FRIEND.

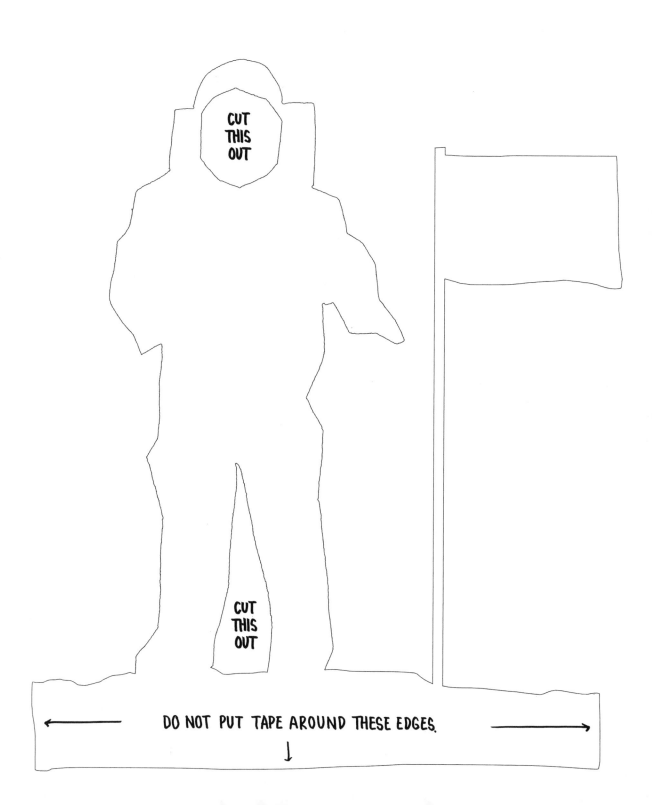

CUT
THIS
OUT

CUT
THIS
OUT

DO NOT PUT TAPE AROUND THESE EDGES.

Curiosity Killed the Marshmallow

DRAW A $ ON A MARSHMALLOW WITH A PERMANENT MARKER.

PUT IT IN THE MICROWAVE ON HIGH FOR 30 SECONDS OR LESS.

WATCH YOUR MONEY GROW.

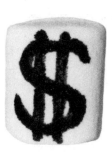 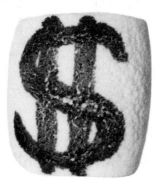 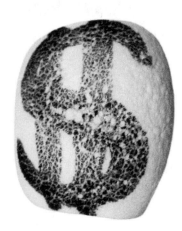

OR GROW TWO HALVES OF A HEART TOGETHER.

Don't eat
your art.

To Kill a Mocking Bear

CUT OUT A DESIGN AND PUT IT ON A PLATE.

PUT A PIECE OF PLASTIC WRAP OVER IT.

PLACE GUMMY BEARS ON THE DESIGN.
MICROWAVE ON HIGH FOR 5-10 SECONDS.

Watch carefully and
do not let it
boil or bubble up.

IF IT DOES NOT MELT TOGETHER ENOUGH,
MICROWAVE IT AGAIN.

LET IT COOL FOR
24 HOURS. REMOVE
PLASTIC WRAP.

Don't eat
your art.

RED AND CLEAR

RED AND GREEN
TREE

PUT YOUR RAKE INTO IT

IN THE FALL, RAKE A DESIGN, WORD,
OR IMAGE INTO A PILE OF LEAVES.

TAKE A PICTURE, THEN FINISH RAKING.

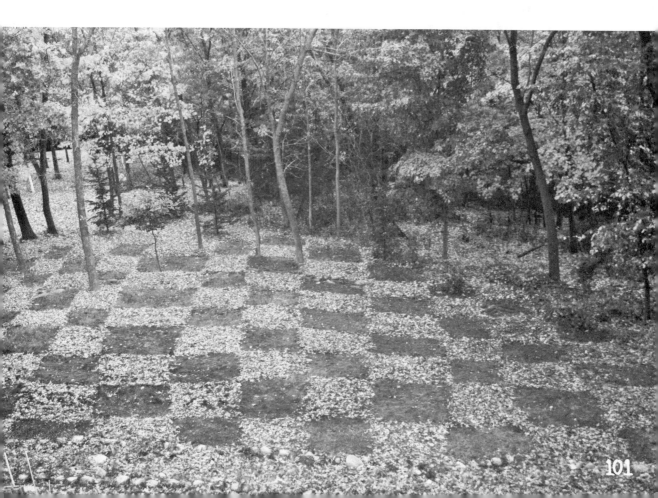

THERE WILL BE OIL

CUT OUT THE NEXT TWO PAGES. ———→

PUT SOME COOKING OIL IN A BOWL.

USE A SMALL PAINTBRUSH TO
PUT OIL IN THE X AREAS.

Be careful where you do this project
as the oil will bleed through the paper.

HANG IT ON A WINDOW FOR
THE LIGHT TO SHINE THROUGH IT.

TEST YOUR SKILLS HERE FIRST.

FILL IN ONE OF THE SHAPES BELOW.

WAIT A FEW MINUTES TO SEE
 HOW THE OIL WILL EXPAND.

THEN TRY IT AGAIN.

WHEN YOU ARE READY,
DO THE FOLLOWING PAGE.

CHALLENGE YOURSELF

with There will be Oil

THIS CHALLENGE YOURSELF IS SO CHALLENGING THAT
IT NEEDS TO BE DOWNLOADED FROM

tattooabanana.com

Forbidden Filter

TAKE AN UNUSED 8-12 CUP COFFEE FILTER.

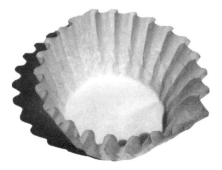

FOLD IT IN HALF.

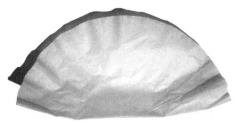

FOLD IT IN HALF AGAIN,

AND AGAIN.

CHOOSE A PATTERN AND CUT IT OUT.
TAPE TO FILTER. CUT OUT THE
BLACK PART AND HANG IT UP.

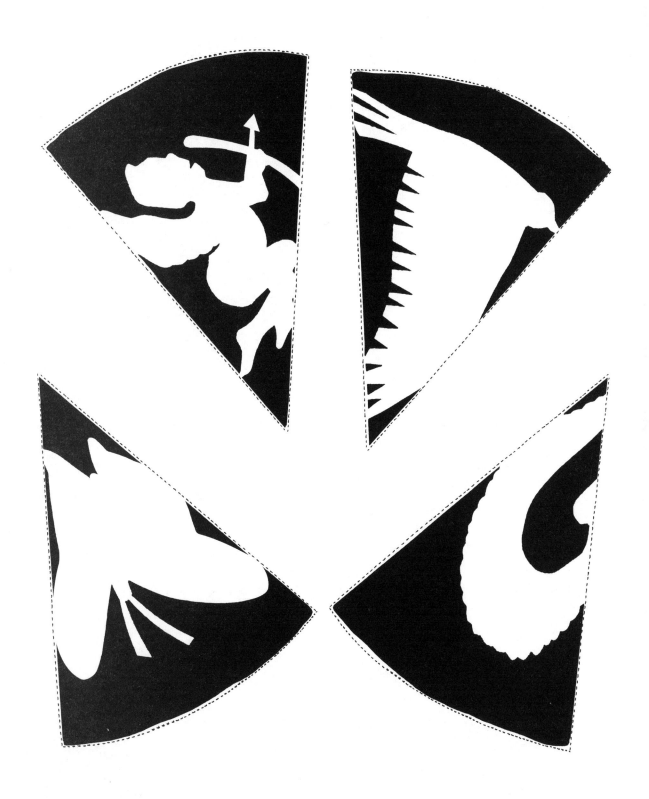

For an aged look, work
with a dried used filter.

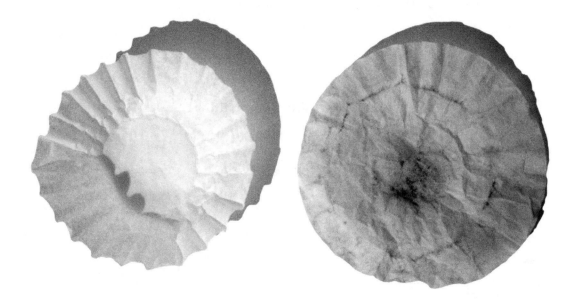

Chip Flicks

CUT OUT THE NEXT PAGE. ⟶

PUT A SINGLE CHOCOLATE CHIP ON EACH X.

MICROWAVE ON HIGH FOR 1 MINUTE.
USING YOUR FINGER, SMEAR THE CHOCOLATE TO
FILL IN THE IMAGE.

Be careful,
it's hot.

DOCUMENT THE COLOR AND
TEXTURE CHANGES
AS IT DRIES.

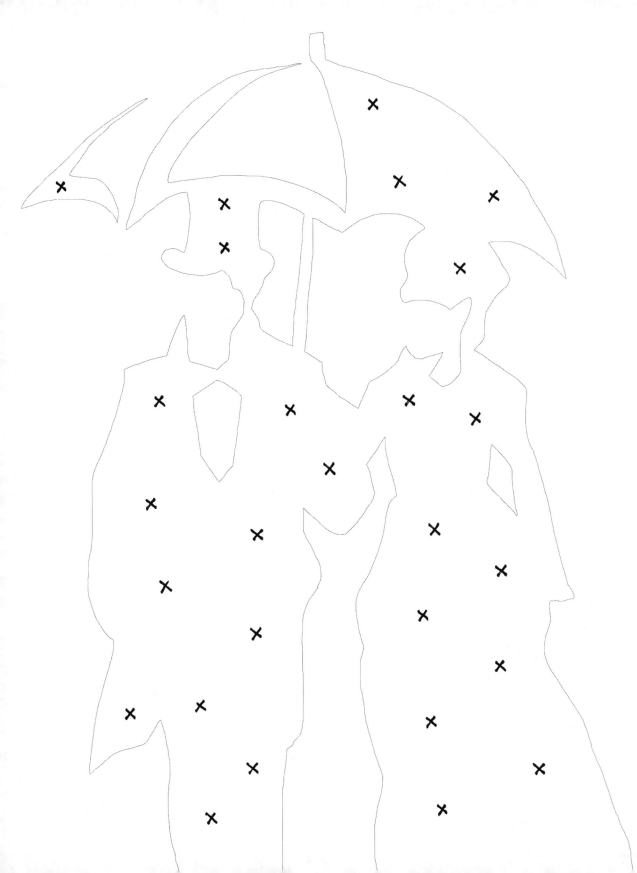

FROM Beauty is in the Eye of the Peeler ON PAGE 69

Transfermers

FIND A DIGITAL PICTURE OF YOURSELF.

CROP IT TO A ONE INCH SQUARE.

PRINT IT OUT USING
AN INKJET PRINTER.

PUT A PIECE OF CLEAR
PACKAGING TAPE OVER
THE IMAGE.

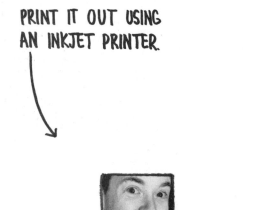

LOAD THE PIECE OF PAPER INTO THE PRINTER AND
PRINT THE IMAGE AGAIN ONTO THE TAPE.

QUICKLY AND SMOOTHLY, PRESS YOUR FOREARM ONTO
THE PICTURE. THEN DO THE SAME THING, IMMEDIATELY,
ONTO BLANK PAPER TO TRANSFER THE IMAGE.

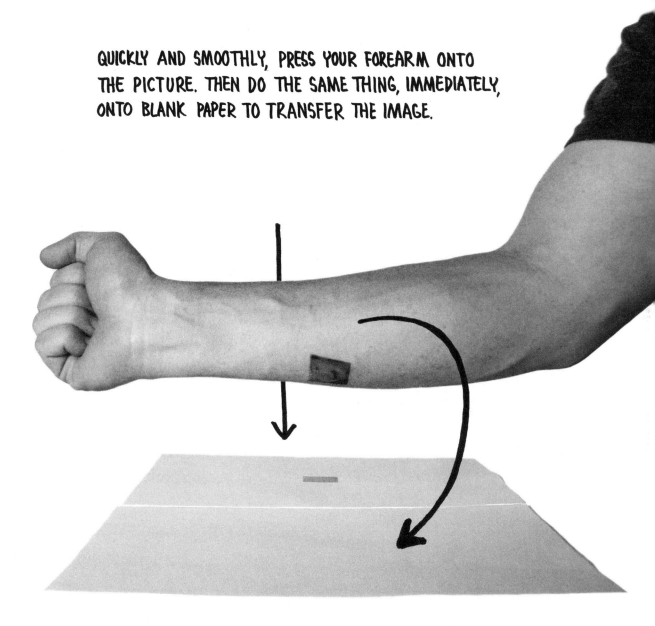

CHECK OUT THE COOL SKIN TEXTURES.

TRY USING YOUR HAND.

A Light Runs Through It

CUT OUT THE NEXT 3 PAGES, THEN USE
A SMALL BOX CUTTER OR HOBBY KNIFE
TO CUT OUT THE X PORTIONS.

TAKE A BLANK SHEET OF PAPER,
LINE UP AND TAPE YOUR 3 CUTOUTS
ON TOP OF EACH OTHER.
ORDER DOES NOT MATTER.

PUT ON A WINDOW
OR LAMP AND WATCH
THE LIGHT SHINE
THROUGH IT.

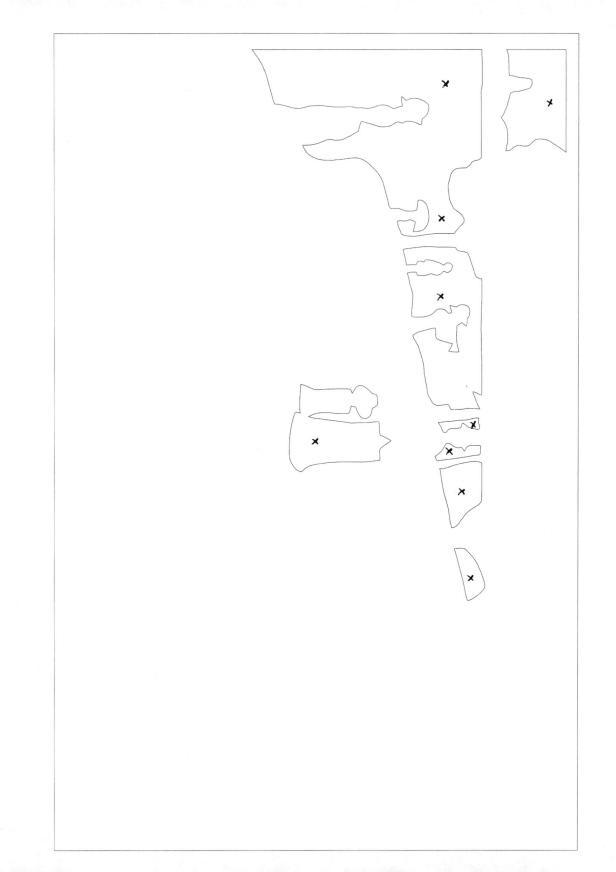

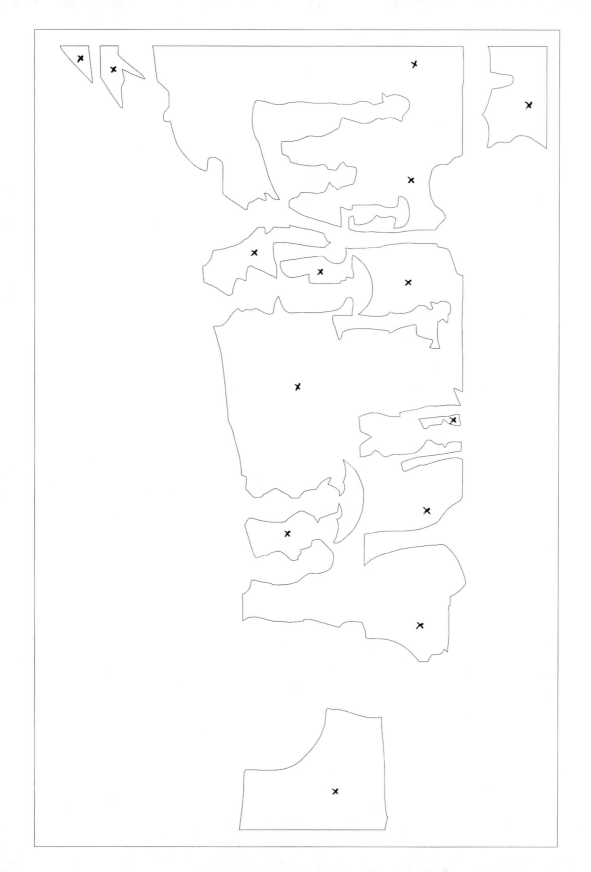

FROM WORTH MORE THAN A GRAHAM OF GOLD ON PAGE 38

Pastafarian

CUT OUT THE NEXT PAGE AND TAPE TO A TABLE.

→

FIND SOME UNCOOKED
ELBOW PASTA.

MATCH AND COVER UP EACH ARCH.

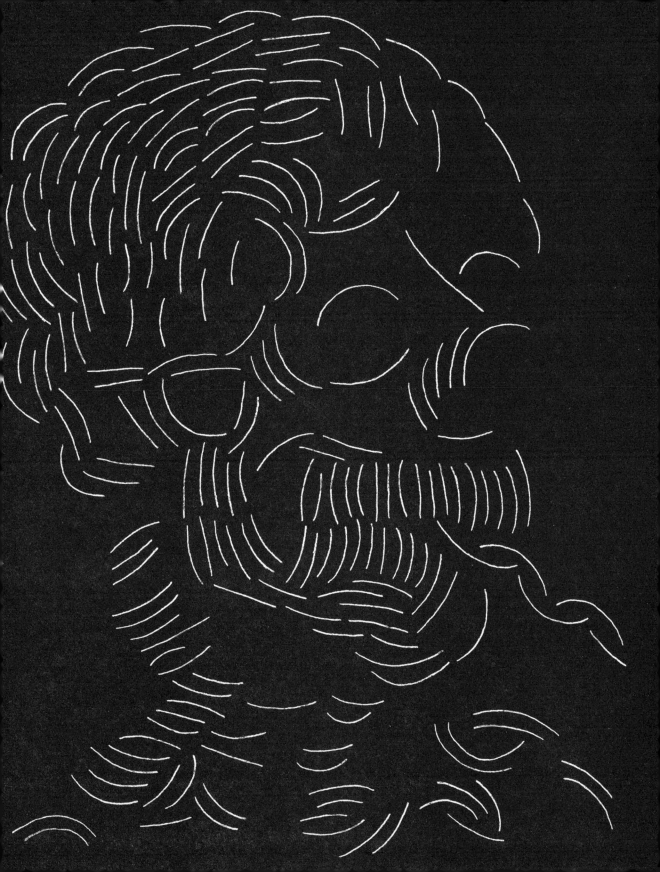

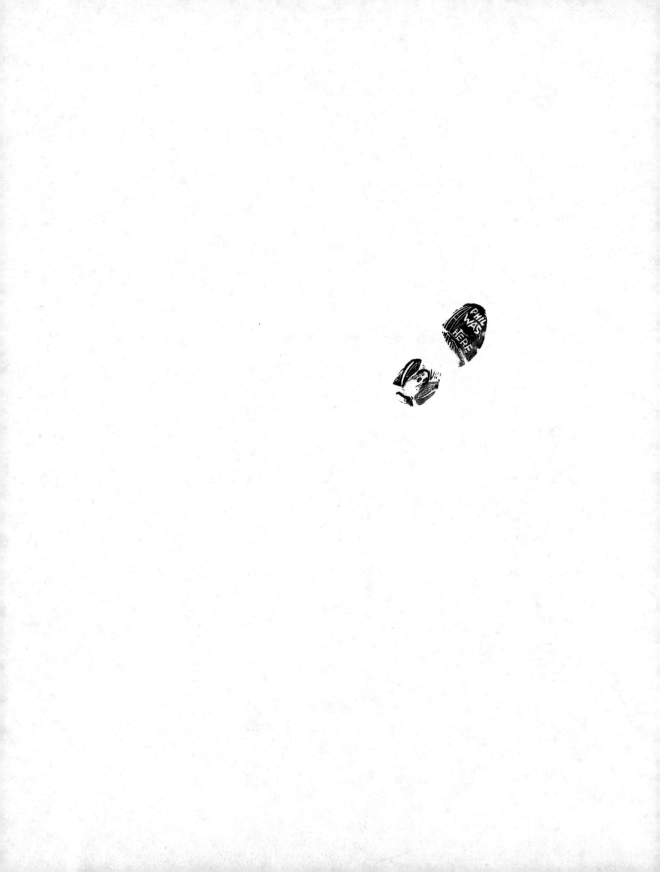

Das Sole

PICK A SHOE THAT HAS A RELATIVELY FLAT AREA ON THE SOLE.

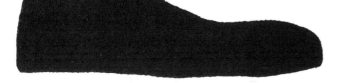

USING A HOBBY KNIFE, CUT A PATTERN, WORD, OR IMAGE ON IT.

CARVE WORDS BACKWARDS.

WALK THROUGH A PUDDLE AND LEAVE YOUR MARK ON THE WORLD.

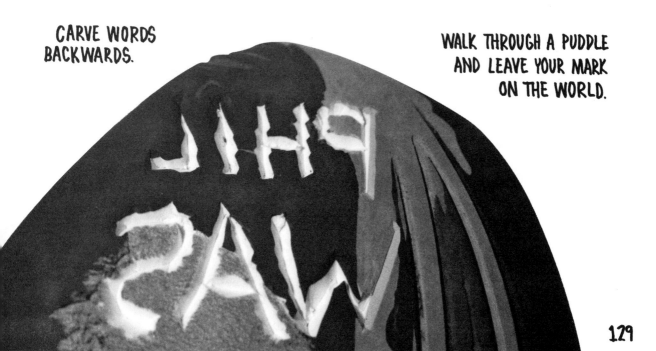

Puddin' Face

CUT OUT THE NEXT PAGE. ⟶

PAINT BY FLAVORS, USING PUDDING.

D = CHOCOLATE M= CARAMEL L= VANILLA

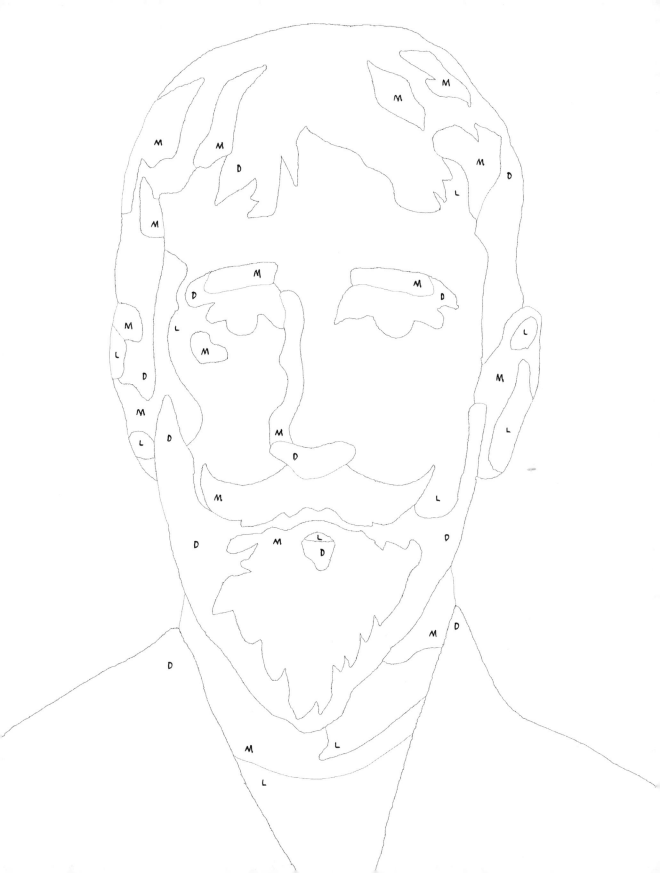

CHALLENGE YOURSELF

WITH Puddin' Face

THIS CHALLENGE YOURSELF IS SO CHALLENGING THAT
IT NEEDS TO BE DOWNLOADED FROM

tattooabanana.com

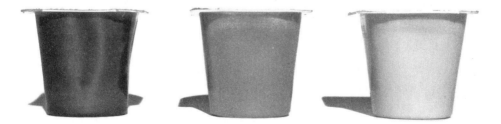

To the Apple of my Apple

CHOOSE A SHAPE AND CUT IT OUT. \longrightarrow

TAPE YOUR SHAPE TO AN APPLE
WITH A PIECE OF ROLLED TAPE.

USING A KNIFE, REMOVE THE
APPLE AROUND YOUR SHAPE.

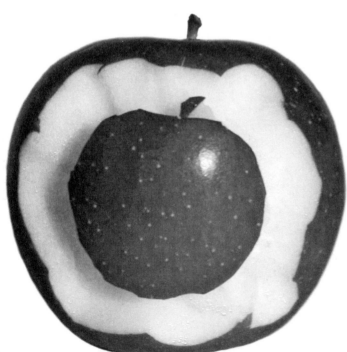

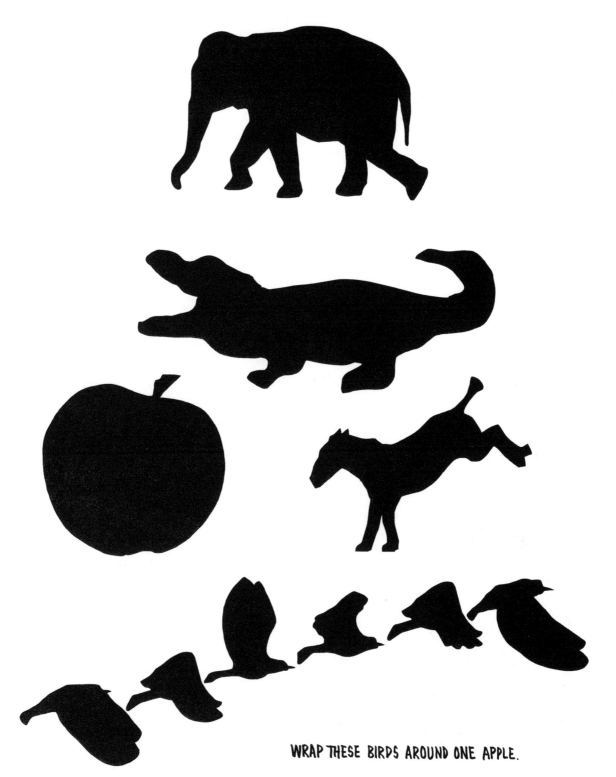

WRAP THESE BIRDS AROUND ONE APPLE.

SUBSTITUTE THE APPLE
WITH ANOTHER
PEELABLE FRUIT. MAKE AN
APEELING FRUIT BASKET.

Picturing a Thousand Words

PICK AN INSPIRATIONAL WORD
AND WRITE IT HERE _____.

NOW WRITE IT OVER AND OVER IN THE X AREAS.
→

LIKE THIS ↘

Beyond the Shadow of a Flamingo

CUT OUT THE FLAMINGO. ⟶

PUT A PIECE OF ROLLED TAPE ON THE BACK OF THE
FLAMINGO, AND STICK IT TO THE BOTTOM OF A SUNNY WINDOW.

MAKE A TEMPORARY SHELF AT
THE BOTTOM OF THE FLAMINGO. ⟶

NOW PUT A PIECE OF PAPER HORIZONTALLY
UNDERNEATH THE FLAMINGO.

TRACE THE SHADOW
CAST BY THE
FLAMINGO ON THE
PAPER.

WAIT TWO
HOURS FOR THE
SHADOW TO MOVE,
THEN TRACE IT AGAIN.
REPEAT
AGAIN
AND
AGAIN

→

TO
CAPTURE A
WHOLE DAY'S WORTH
OF SHADOWS.

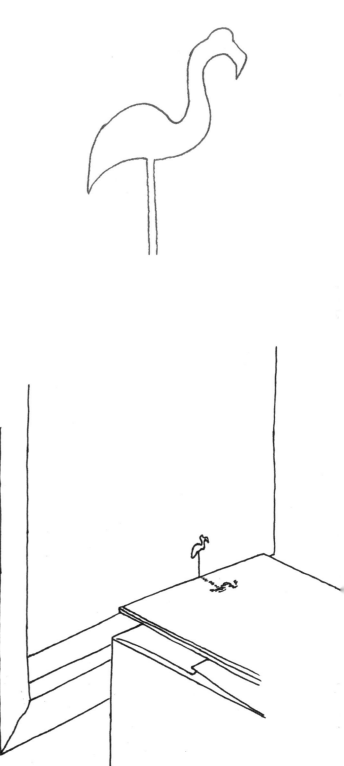

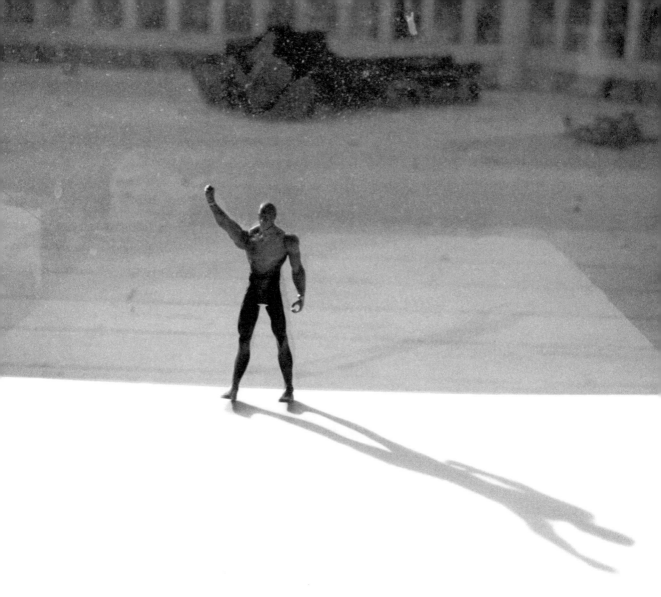

TRY THIS WITH A SMALL OBJECT OR ACTION FIGURE.

Pressing Matters

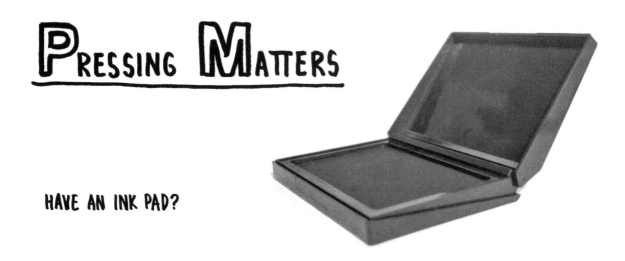

HAVE AN INK PAD?

CUT OUT THE NEXT TWO PAGES ON THE DOTTED LINE.

TAPE THEM TOGETHER ON THE BACK.

USING THE INK PAD,
FILL IN THE X AREAS WITH FINGERPRINTS.

To see the image more clearly,
view from farther away.

144

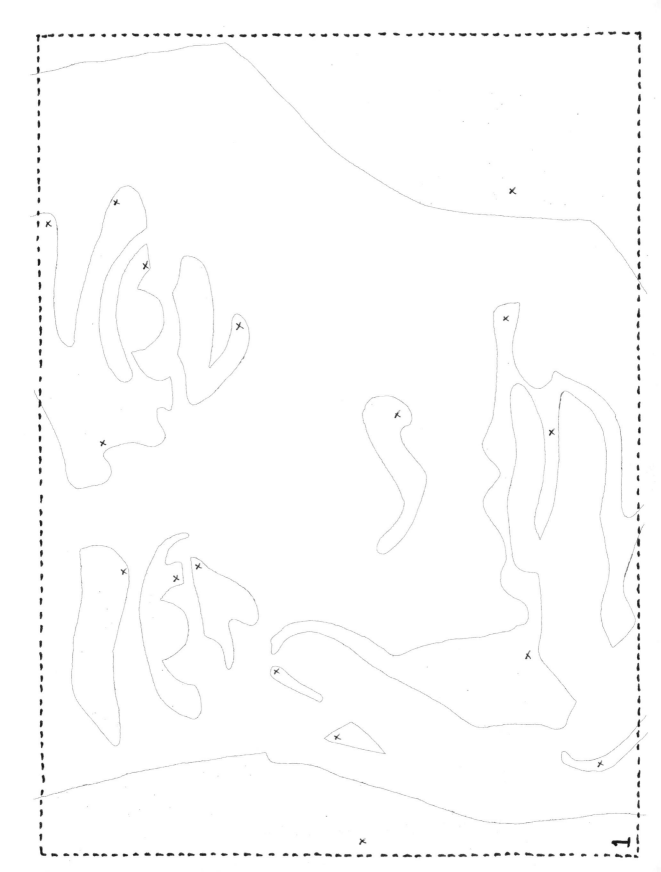

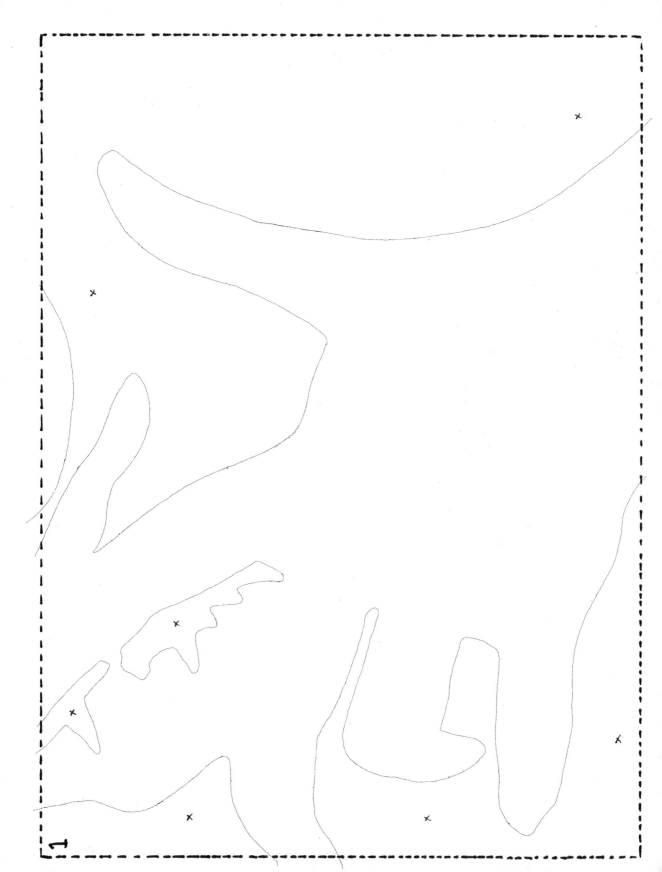

WITH **PRESSING MATTERS**

THIS CHALLENGE YOURSELF IS SO CHALLENGING THAT
IT NEEDS TO BE DOWNLOADED FROM

tattooabanana.com

Lincolned In

TEAR OUT TEXT FROM A MAGAZINE,

AND COVER THE X AREAS. ⟶

Trim for details.

FROM 101 USES FOR MONA LISA: #38 ON PAGE 88

As the Marshmallow Turns

TAKE THIS SIZE MARSHMALLOW →

PRINT A 1"x4" PHOTO
ON AN INKJET PRINTER.

PUT CLEAR PACKAGING TAPE OVER IT.

LOAD THE PAPER BACK INTO THE PRINTER AND PRINT
THE PHOTO AGAIN, ONTO THE TAPE.

ROLL A MARSHMALLOW OVER IT

A ROLLED MARSHMALLOW

SIDE	FRONT	SIDE	BACK

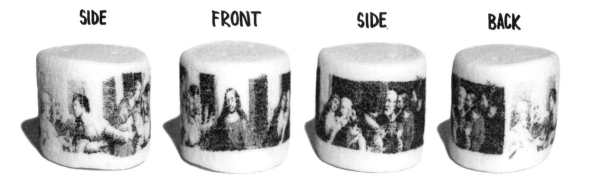

Don't eat your art.

STACK 'EM

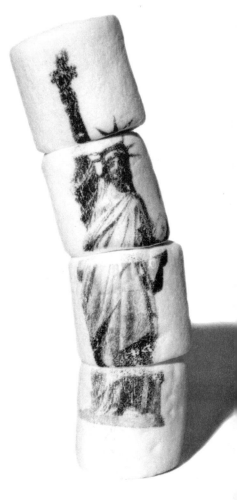

OR LINE UP SEVERAL.

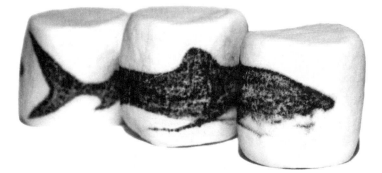

AUTHOR PHOTO

IN LIEU OF A PHOTO IN THE BACK OF THE BOOK,
THE AUTHOR GIVES YOU THIS MAZE.

FOR THE SOLVE, VISIT TATTOOABANANA.COM

ABOUT THE AUTHOR

Phil Hansen is an internationally recognized multimedia artist who works at the intersection of traditional visual art, pointillism, and offbeat techniques, using media that connect to the subject matter, such as karate chops, tricycle wheel imprints, burger grease, and worms. He is most widely known for his meta-art, videos that document the creation process. His breakthrough piece "Influence" — a time-lapse video of Hansen painting 30 pictures on his bare chest, one on top of another — shows that art is action, not just result. His art can be participatory as well, soliciting direct input from his worldwide following. The end result is a new audience engaged in art to a degree that would have been unthinkable a decade ago. Visit his website at PhilintheCircle.com.

FOR MORE, VISIT
tattooabanana.com